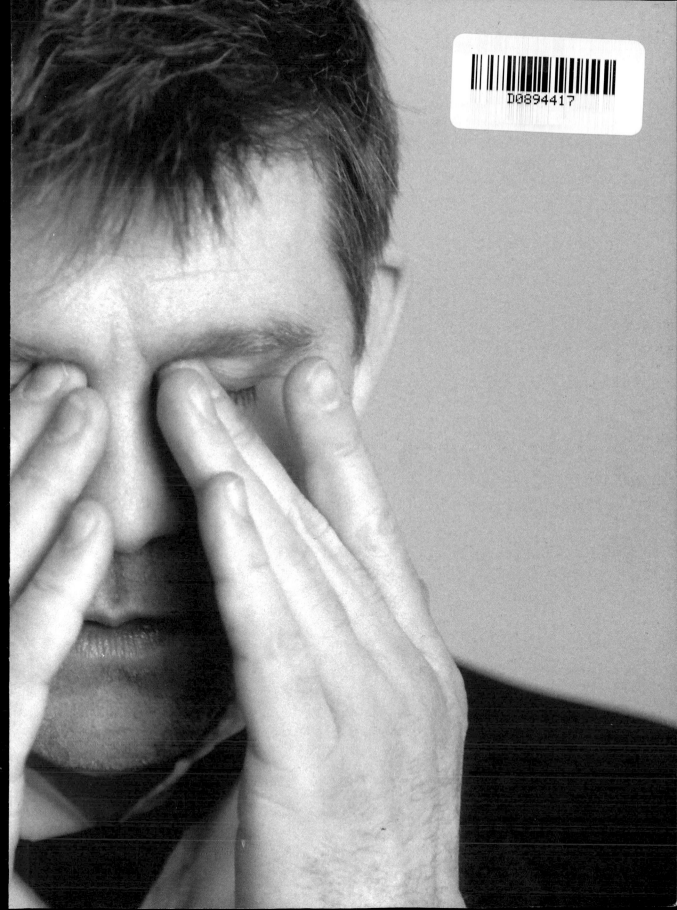

# SOUNDSYSTEM

# LCD

## BY RUVAN WIJESOORIYA

**pH** powerHouse Books

Brooklyn, NY

# INTRODUCTION BY JAMES MURPHY

"Well, it was due a couple of days ago, but I didn't want to, you know, hassle you."

Ruvan showed up at the studio today. Mind you, he wasn't invited. He ambushed me. I knew he needed the intro to his LCD book, and I knew he wanted me to write it, but I was busy mixing the fucking thing for the 30th time—this time for stereo vinyl—and I was finishing up and getting ready to leave town in the morning. And totally dodging my friend. "I knew I had to get in your face." Ruvan has been getting in my face for years. He has taken several thousand pictures of LCD over the last few years, and he whittled them down to literally hundreds for this book, laboring

over it, and arguing between, I guess, what was "interesting" and what was a "good picture," while occasionally sending me a text or email (which would go unanswered) until he finally just showed up at the studio, with a sort of "sorry about this" grimace on his face, and a shitty backpack with his laptop in it. "I literally have five questions for you. If I ask them and you answer them, I'll leave you alone."

In other circumstances, this is basically illegal. It's stalking. But it's my friend Ruvan, and I'm caught. I tell him I have errands to run and that he should come with me, and then I can deal with his questions afterwards, but the truth is, I don't know

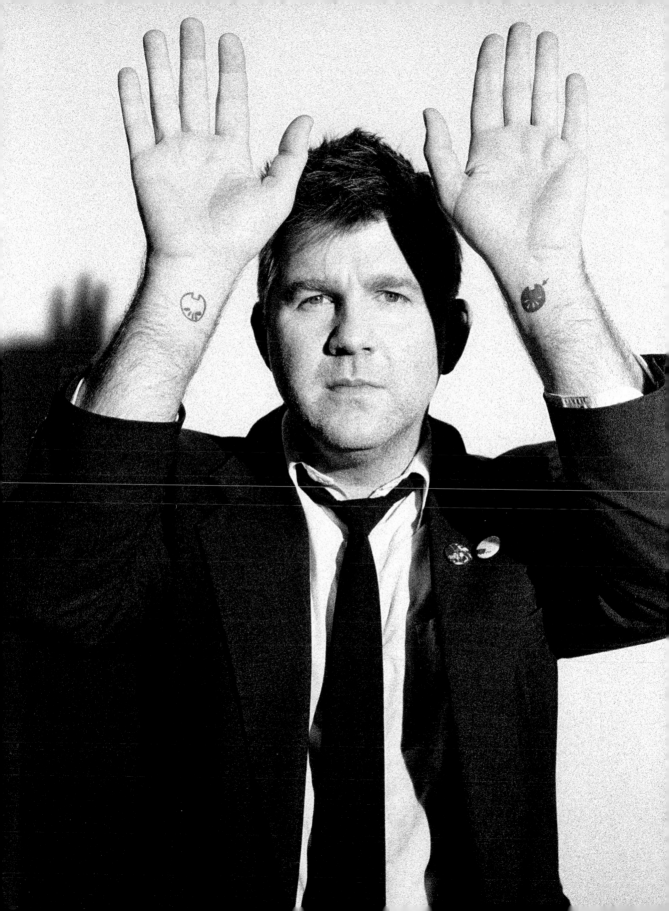

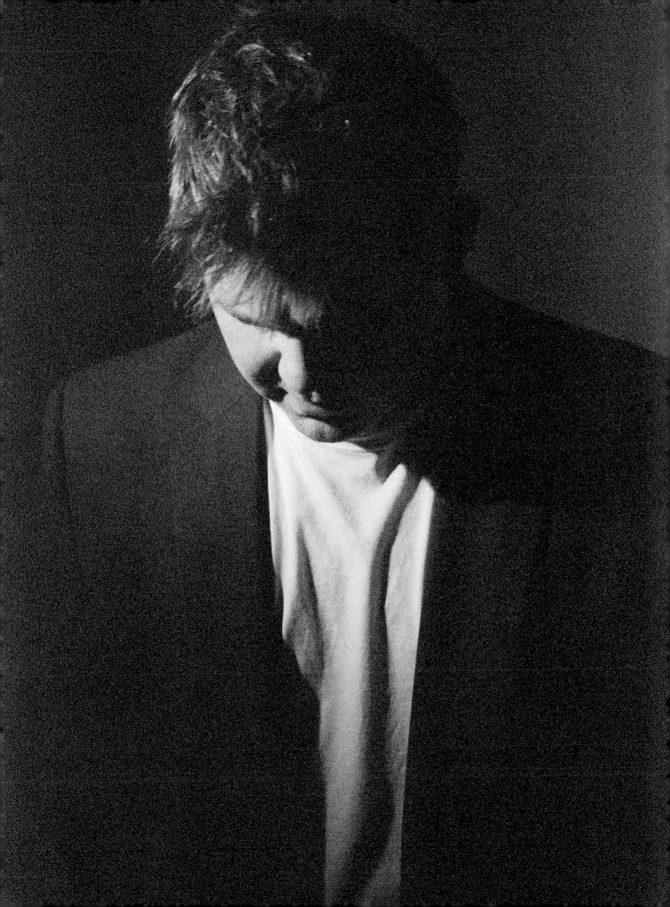

what to say. He feels like the book needs an intro from me, and I'm not sure I agree. He's got a paper with scribbled questions on it. "What was it like going to your first concert?" "How did it change you as a person?" We're back at my house and he's gamely trying to ask me this interview drivel. And I can't answer. He's closing his eyes because he knows that it's a ridiculous situation and that I'm exhausted. But it's falling apart because the entire question-and-answer thing is kind of a betrayal of our friendship, really. Ruvan and I are friends. We've been friends for a long time now. I don't even know how long, but long enough that he shouldn't be sitting in my living room asking me magazine questions and expecting answers. So I tell him that I'll write something before I go to sleep, and he goes away, not sure if I'm telling him the truth. I'm not so sure either.

I'm not so sure because I don't know what to say. I don't know that these pictures need contextualization. We were a band, and these pictures make it clear we were a band. We love each other, and we like being together, and we loved being a band, and worked really hard at it, and there are people who came to see us who appreciated that, and that constituted this sort of mundane/magical experience for all of us. And then we decided to not do it anymore. Which is ok.

Ruvan wanted to get to the heart of what I felt when I was young and going to shows, and how it might affect how we ran the band, and I kind of blew him off. But it's a good question. I loved music. I loved the volume and how it made me feel crazy and alive and present. I loved my first show (the Ramones at the legendary Trenton club City Gardens, in like '84) and I loved all the bands that I invested in. And I wanted to have a band that never betrayed the things I loved about bands when I was young. I realized early that we couldn't make everyone happy (I mean, just look at the internet), but we could make me-at-15 happy, and I'd do whatever I could to accomplish that—to not betray what I loved (and still love) about a band. We did our best.

But I also remember something else which really affected me at that age. My older sister (Nancy—no, not Nancy from the band) was nerdy, smart, and cool, and had a lot of friends in high school,

and I remember going to this "senior night" thing when I was in eighth grade to see her class prepare to graduate. There were all these stupid skits and songs filled with inane inside jokes and tedious popular girls in sunglasses lip-synching to idiotic hits riddled with double entendres, etc., and I hated it. That is, I hated it until they put on this slide show, with some saccharine soft rock song or something, and showed all these pictures of everyone doing normal things. My sister had all these friends (I still know all their names: Kevin, Patrick, Lisa, Danielle, Lorraine, Sean, Nate… It goes on. She had a lot of friends) and there were pictures of them all hanging out and laughing. There was one in particular which really affected me of my sister sitting cross-legged on a desk with some friends, smiling. I was really a lonely kid at that time, and I just couldn't imagine having these people around you who you trusted and felt comfortable with, who trusted you and liked you and showed it. It was inconceivable. I sat there with my parents, who had dragged me there with them to show some support for my sister, depressed. Or maybe hopeful. Like, "When I get to 12th grade, I'll also have friends like that." Well I didn't. I didn't then, or in college, or in my 20s. I didn't in my punk bands or in my studio. Or anywhere. Until this fucking LCD band.

When I look at these photos, I wonder if I'm seeing it like I would have seen photos of another band when I was young, or if I'm seeing them like I saw that slide show. And I think it's more like that slide show. I finally had that time where I could laugh and humiliate myself with people I totally trusted, and loved, and hated, and fought with, and made music with. Way later than I'd hoped, but better late than never. Somehow, I think that total jerk Ruvan, who has blinded me with flashes and drunkenly berated me, who has tried to get me to go out way after I've gone to bed, who has spilled drinks in my house and hugged me while yelling, managed to get so many pictures of us that show that feeling. It's my band. And my friends. And it's all there. And it doesn't need shit for contextualization.

I hope you have friends like that. And I hope one of them is taking pictures.
hearts
J.

# PATRICK MAHONEY

**What is your role within LCD Soundsystem?**
I play the drums.

**And what else do you do in your time?**
Dad to an eight-year-old boy, and a visual artist sometimes, too. I make sculptures.

**How did you meet James?**
He engineered and produced my first band's first record—the Les Savy Fav debut, *3/5*, and one single.

**Did you sing in that band?**
I didn't—I played drums in that band. I sang in a hardcore band called Distorted View when I was 14, but we never recorded anything with James Murphy.

**And you've been with this band since its inception?**
Yeah. It kind of started as this project James and I were doing together years ago that we called LCD Soundsystem. Then I moved away and he started writing songs under that name. I lived in Florida for a year and when I came back the first couple of singles had done really well, so he asked me if I wanted to be part of a live thing and that was the beginning of this band and its current incarnation.

**What was your favorite song on the first album and what was your favorite song on the second album?**
Hmm. I like "Beat Connection" a lot—it's a good song.  On the second, it is a toss up between "Someone Great" and "All My Friends."

**What are some of the best things about being in the band?**
All the personalities involved. It's just interesting funny people who care about each other a lot and take care of each other. It's pretty awesome to travel with a group of people who are your close friends and to find a creative project that lines up with the weird ideas we all have about music and art and stuff.  It all seems to fit nicely, where we can realize all of our bad ideas.

**What is the process when a bad idea is happening? Do you try to turn it into a good idea or just throw it away?**
I feel like we get a lot of our inspiration from people who don't really know how to do it right so they just try and fake it in a certain way, or they just completely misapprehend what "doing it right" is so they do it in their own really idiosyncratic way. I never liked really drummerly drumming where it's flashy and feely, and I don't like jazz-fusion drumming, for example. I like drummers that sound like drum machines—as an example of a non-traditional rock approach. I get to do that in this band.

**What is punk, and what are the elements of it in LCD Soundsystem?**
What people call punk now is so ninth generation or whatever that it's just like a retro act thing. I mean if you are saying punk like Iggy Pop that's one thing, but if you're saying punk like Angry Samoans or Black Flag or something, that's another thing altogether. The punk that I grew up on, after its first few breaths, instantly ossified into this essentially teenage music. It is terrible, it is really boring, it hasn't changed. I mean there are bands that put out records now that sound like… Jesus, they sound like Youth of Today, who are truly awful, but who I loved as a kid. I went to their shows. There are great bands; I love Bad Brains. But punk was instantly post-punk, instantly PIL, and it didn't last very long. And everything else means a lot less, culturally. But it affected things. I think that very much dance music, a lot of disco, especially sort of weird, underground disco, and certainly house music, is really punk in its attitude. It's repetitive and stupid and awesome and moving. So yeah, punk.

**So what's conservative about the band?**
That's a good question. What's conservative is that it hews to James' taste, but he has really good taste so I'm not mad at that. I don't really know. If our tastes were to ever diverge significantly, I think I would probably not do the project because it's his thing. I think what's conservative is that James has golden-era rock music ideas about what sounds good. I mean this record is not gonna sound like The Eagles, but the recording quality will probably approach that. The production is as tinkered over and troubled with as a [Fleetwood] Mac record, which I think is awesome. Especially for these gestures that are pretty small, but if they are then rendered beautifully it's a cool combination.

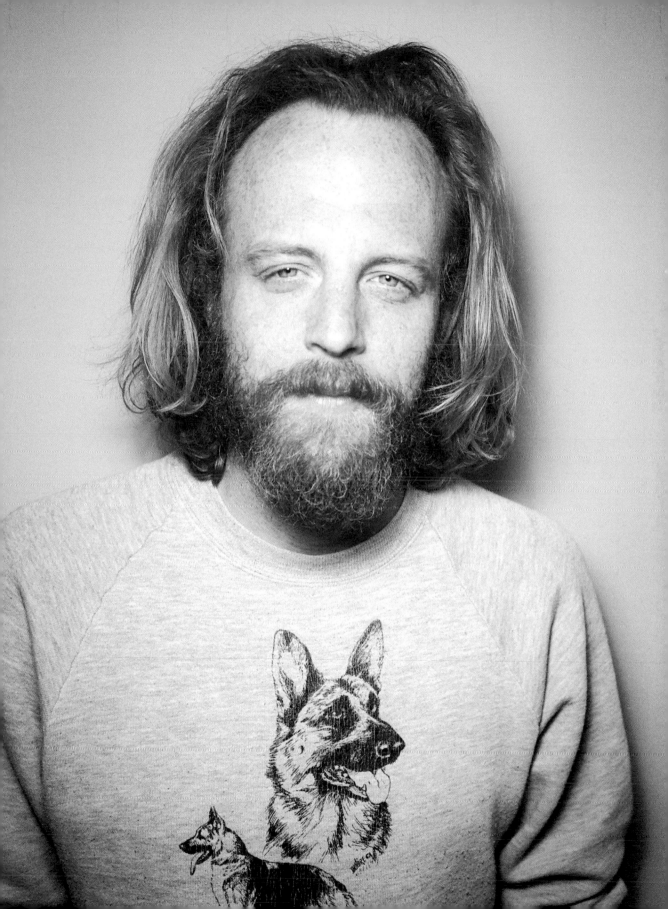

# NANCY WHANG

**What do you do for LCD Soundsystem?**
I play keyboards and sing backup vocals and am the resident female. That's it. That's the scope of my job.

**When did you first meet James and when did you first get involved with LCD Soundsystem?**
I met James in 1999, 2000—I can never remember. I think it was 2000, at a party in the Lower East Side that was being thrown by the place where I worked. I used to work for this artist who also published *Index* magazine. It was the magazine's second anniversary and the assistant editor, Steven, had known James from way back. Anyway, he introduced us at the party. After that it was one of those things where you break the meniscus or whatever, so every time I'd go out I would see him. We kept running into each other, and I had simultaneously met The Rapture separately. Coincidently, that's when James [as part of DFA] and The Rapture started working together—way before LCD Soundsystem.

**What was your role for the first album and how has it changed in terms of your involvement with the most recent album?**
The whole idea with LCD was that it was just going to be a side project to all of our lives. James was making music and he wanted to make a record, so he put out the first 12 inch—which was "Losing My Edge" with "Beat Connection"—and it did pretty well. Then he had this idea that maybe he'd put a band together, but it was just going to be an excuse for all of us to take a break from our normal lives, like Army National Guard: a couple of weekends a month, a couple of weeks a year. That's really all it was. Our first show was just… "Do you want to go to London and stay at a fancy hotel and play this weird show for free? You'll get your airfare and your hotel room paid for and your drinks and maybe a dinner…" and we were like, "Fuck it, why not? I hate my job so let's go!" For the first year and a half, two years, it was just flying off for the weekend doing these weird random shows just for kicks, and that's it.

**What was the lineup for the first shows? Who was playing?**
It was James, Pat on drums, me playing the keyboards, Phil Mossman on guitar, percussion, and some keyboards, and then Tyler [Pope] playing bass—just the five of us.

**And that was when?**
Our first show was at the Great Eastern hotel in London. I guess it was 2002.

**Who are the other players in LCD now?**
I think anybody who has ever been involved with the band has been a really integral part. Phil for the guitars. I always think of Tyler as our secret weapon. Actually our real secret weapon is Steve Revitte, our sound guy. He has been with us since almost the very, very beginning. He's known James for a million years. He started doing sound maybe a year, a year and a half into it. Our first sound engineer was Paul Epworth, better known as the producer of Adele's records, and also Bloc Party's. Paul used to be the house sound guy for this tiny club in East London called 93 Feet East. He was doing sound there and James was on tour with The Rapture. Paul was doing front of house for them. I guess James saw something in him, realized he was a good engineer. After Paul was on tour with The Rapture, LCD pinched him and he toured with us for about a year or so…more than that. Now, Paul Epworth has won several Grammys, and it is crazy he was our first front of house engineer.

**When did it start to become serious?**
I don't know. It's hard to say. It was always serious. Even though we weren't trying to be anything in particular, we weren't doing anything with a goal in mind, we had opportunities and we just said yes to them. We weren't trying to fabricate or strategize or create situations. People reached out to us and we just said yes. Despite that though, in everything we did, we always meant what we were doing and it was always serious. We always tried hard and always tried to be as good as we could; to have as much integrity, to have as much passion as possible. It was always meaningful. It was always a big deal, I think especially because every show was like, "This could be the only time we ever do this weird thing so let's make it fucking count." I think when it became really serious was when we decided we were going to play our last tour, so 2010. James made the record in 2009 and it came

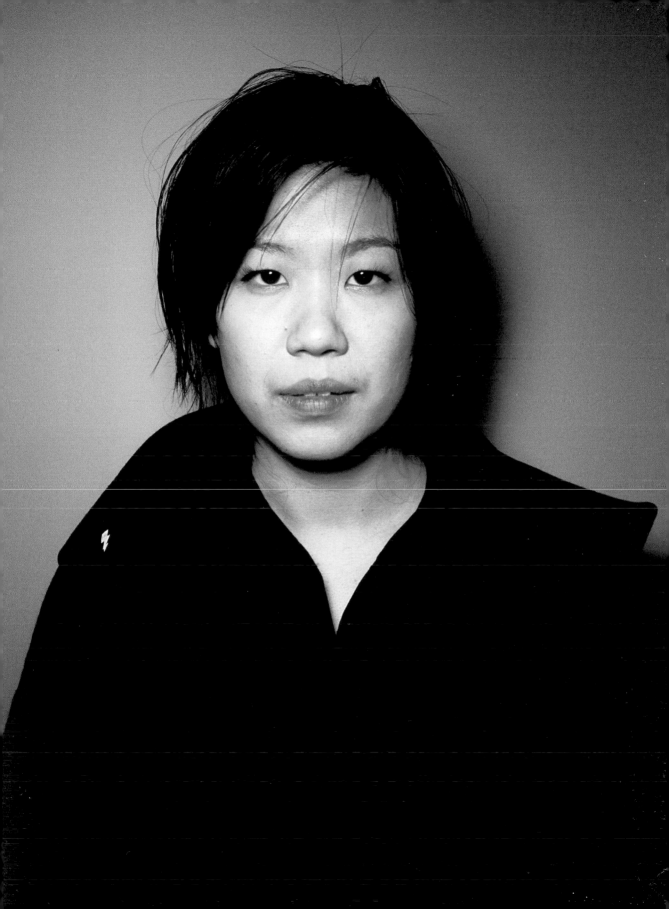

out in 2010. When James decided he was going to make *This Is Happening*, that's when it got really serious. The first record was a first record and it seemed like a fluke; the second record was supposed to be the last record, but it was like, "Maybe something else will happen after *Sound of Silver*, maybe not."

**What do you think propelled James into doing the third album after the second album?**
I think there was some closure that needed to happen…musically, personally. On the second record he said a lot of stuff, but I think it was just this idea that there was one more thing left to say. From a musical perspective, the first record was just James by himself in a studio making all this music and it sounds the way that it sounds because of it. The skeleton of the record was made, and he brought it to everybody else. We'd listen to all the songs and learn to play them, but that was basically after the fact; the songs were already written, for the most part. Then we took those songs, went out and played live together as a band, and I think that really informed the way James thought about writing music for the next record. "I have these songs, I have these ideas, but now I also have to think about this live band and how these songs are going to be played live." I think *Sound of Silver* was much more focused on the live element in terms of the construction of the songs, the output. There are the sounds that happen in a studio, but how do you translate that into a live sound? I think it is a lot more reflective and a lot more collaborative, too, because it was going to be the last record. Also, the time that we spent on the road with *Sound of Silver* was probably double what we spent with the first record. There really was a different feel. We got tighter as a band. We really developed the live aspect—the live incarnation of LCD Soundsystem. When we finished the tour for *Sound of Silver*, James said that it was going to be our last. I believed he meant it, but I didn't believe that it was actually true. I knew he didn't know what he was talking about. It was at the beginning of 2009 when he said he was going back to the studio to make a record and I was like, "I fucking knew it!" But when he said that, I also knew it was going to be the end. I didn't think that it would be, "We're going to do this one and we'll see what happens." He was so adamant about *Sound of Silver* being the end; with *This Is Happening* he really meant it.

I think *This Is Happening* is supposed to be a period on the arc of a career—a very specific project. James was very conscious that it was going to be the last record and an end to all the time we had spent on the road, playing together, playing live, so I think making this record was way more collaborative and thoughtful. What does it mean to not just play with a bunch of people but to be a band and play with people that you love and care about and respect? How do you honor that collaboration, honor that time we've spent together?

**What projects do you do, other than LCD Soundsystem? What's the scope of your musical career?**
I also play with The Juan MacLean. That's actually what I was doing when James was in LA recording *This Is Happening*. I was on tour with The Juan MacLean so I didn't get to spend as much time in LA as I would have liked. Since LCD's been over, I've been DJ-ing. I throw my voice into songs whenever people ask me— Holy Ghost!, Shit Robot, Soulwax, but that's old news.

**What other New York bands influenced LCD Soundsystem?**
Everything that we did was kind of, "We don't want to do that, we don't want to do that, we don't want to do this, we don't want to be like them, we don't want to do it this way." On one hand we didn't want to make a joke out of it or ourselves, or set ourselves up for being made a joke of. On the other hand, because all of this came from indie/ punk rock, we were very careful not to be too indie or too hater-y or too cool for school. We always had this arbitrary set of rules and guidelines that we lived by as a band. There were certain things that we had to adhere to. There was no posturing, no hyping up the crowd in the typical way ("Hello city X, you ready to party?"), none of that. No sunglasses on stage unless it was actually unbearably sunny and you actually couldn't see. If you are playing a nighttime show indoors you're not going to be wearing fucking sunglasses— you'd look like a fucking asshole. Ultimately, meaningless rules, but because they existed we gave them meaning and they gave us meaning. We were also trying to set ourselves apart. We weren't trying to be a rock 'n' roll band, we were never trying to be rock 'n' roll. We were never trying to be anything. At the time there wasn't really anybody that we were thinking of. I guess there were some bands that other people had toured

with, bands like The Jesus Lizard and Six Finger Satellite. Chrome always came up because they were really scary and they didn't give a fuck about their audience at all. They didn't want fans. In fact, they hated their fans. They wished that their fans would fucking die. They were all fucking assholes. They were all crazy junkie assholes. There was also this band Dungbeetle, from New York, that James always referenced and idolized. They are, hilariously, very successful in their own fields holding very prestigious occupations and careers. When they were in Dungbeetle they were a fucking menace. Not that we wanted to scare people away. There was just this idea of wanting to be terrifying. That's the thing—as much as we wanted to be terrifying, we're also really nice people. We like to party. We like to go places with good people and lots of different people and just dance and hang out and have a really good time. I guess maybe the idea of being terrifying is making people feel out of their comfort zone, making people feel uncomfortable because it's not what they are used to—not for the sake of making them uncomfortable, but just to shake them up a little.

**What differentiates LCD from other great bands?**

Honestly, I think the one thing that sets us apart from any other band is the fact that we all really like each other very much, and we always have, and we still do. We've never fought. We've never had any kind of falling out or anything. We spend a lot of time on tour with each other and in very close quarters for extended amounts of time. There is small bickering. You get fed up just because you miss home or you are tired of living out of your suitcase or just haven't really slept or you've been hungover for five days in a row. Whatever reason, you kind of get to the end of your rope and you just need to take a walk by yourself for an hour and when you come back everything is cool. I honestly think that the most unique thing about LCD Soundsystem is the fact that we all love each other, we all respect each other, and we always have each other's back. There's just never been a time when it didn't feel worth it. We were always together in everything we did. We're in this together no matter what happens. If it gets too crazy and shitty, and if we'll end up miserable, we'll stop.

**No one seemed miserable at the time you guys did stop. Was anyone miserable or possibly hiding any misery?**

I don't think so. I was fucking thrilled; not because we were finished, but because [our final] show was such a big deal. Not just in terms of the fact it was at Madison Square Garden, but the scope of it: it was three and a half hours long, we had all these different sets [of songs], we had all these different guests and performers, we had sets built, and we had to learn so many new songs. We learned "45:33" in a matter of two weeks. The last show, more than being the last LCD Soundsystem show, was kind of this culmination, the payoff for all the work we had done. All the rehearsals that we did, the mapping out of each song—we probably spent three days just figuring out the set list, the song order, what songs to play during each portion of the show, when to take breaks and all that stuff. Everything was so much more involved than any other show. We had four shows at Terminal 5—kind of dress rehearsals—so when the final show actually happened it was this joyous occasion of seeing the fruits of our labor. I was really excited to finally put it out there, and I think we all kind of felt the same way. We'd known for over a year that tour was going to be the last tour, and we'd known for a good six months that show was going to be our last show. We had a lot of time to get used to the idea that it was going to be the end. At that point it was a matter of putting on the best send-off we could.

**Are you disappointed that there is no more band?**

In a way, of course I am. It was such a huge part of my life and it was really fun, really gratifying. I feel like I can say this because it's not my music, but the music is fucking amazing. I was always thrilled and felt privileged to be able to play that music. And play it in front of people. Not even that—that was actually secondary to playing it with the rest of the band. The most exciting part of playing live was being on stage with everybody and playing the music together, making the thing together, or recreating the thing together. So it was extremely gratifying to play live with everybody in front of all these people who are really excited. I can't really describe that type of energy and I don't know how I'm ever going to recreate that. Disappointment isn't the right word. I miss it. I pine for it, you know? I also knew that we weren't going to be able to keep doing what we were doing the way we wanted to do it, forever.

# KEITH WOOD

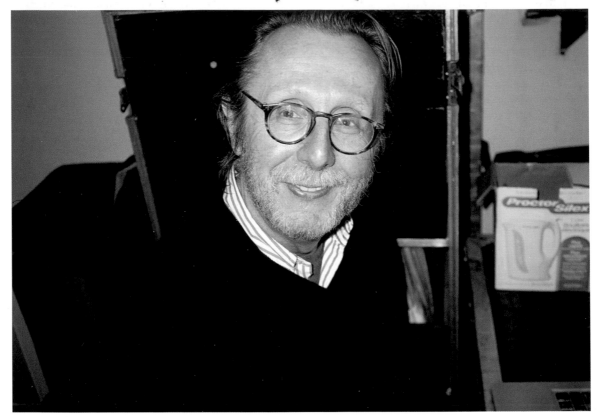

**What is your role within LCD Soundsystem?**
I manage James and LCD Soundsystem.
**What's the difference between James and LCD Soundsystem?**
Well James has a career as a producer, composer, remixer, and a DJ, outside of LCD Soundsystem, where he is the producer and the writer and the performer and whatever.
**Are some of the LCD songs co-written? How does that work?**
James pretty much writes 95 percent of everything. Sometimes people make contributions and James is very gracious with the way he gives people royalties for songs and things like that, but he owns 100 percent of the copyrights because essentially they're his songs. People make contributions and he gives them royalties for those contributions, which a lot of people don't do.
**Have you managed any other bands before?**

I looked after a band called Calla, a New York band, for a very brief moment. And I looked after The Kills, who were friends, for a brief time also. I got into management when I left Rough Trade. With Calla it was just to help them out with a new record, same thing with The Kills…and actually, the same thing with James, except three years later it has become a full-time job. "Full-time job"—understatement of the year.
**How did you get into the music business?**
Music has always been my second love but basically I'm a painter. I was in New York in the 80s and broke, so I got a job to pay the rent working in a record store that is now Bleecker Bob's on West 3rd Street. At the time it was called Bonaparte. So I got a job at a record store—which was great—and the record store started a distribution business out of the back room. I wasn't exactly the sort of 19, 20-year-old New Romantic in leather trousers

they were looking for to run the store! I was this 32-year-old hippie beatnik mod. I didn't really fit the bill at all, so I was soon shunted back into the distribution boiler room to sell records on the phone in a kind of *Glenngarry Glen Ross* situation. After that I went to work for Virgin Records and they started this company called Caroline. There were three of us and we sold disco records out of a garage on Perry Street. Caroline grew out of that, literally selling disco records. We started Caroline [distribution] and then started the Caroline label and it was a really interesting time because there was an amazing infrastructure for independent music in America. There were a lot of independent mom-and-pop record stores, very strong independent underground press—lots of magazines, big, small, glossy etc. College radio in those days was extremely vital, very strong. They would not play anything that was on a major label. Big change from now. So it was terrific for the independent scene because you essentially had retail—focused retail not rack stores—nationwide, great press, and you had radio. So there was this amazing infrastructure to build, develop, and sell records. And there were lots of bands. And many were really good. And there were lots of independent labels. Labels like SST, Restless, Suicidal, Homestead (which eventually became Matador), Merge, Touch and Go, and of course, Sub Pop. So that was a very interesting time to have been involved in that world. The Caroline label came quite late in the day but became a real player.

**And you were how old at that point in time?**
120. (Laughing). I was like, how old was I? 40? I always felt I was ten years older than I should have been for the gig I was doing. Maybe 20 years, some people would say 20 years.

**Ten! Be fair! Ten. So you must have a relationship with Richard Branson then right?**
Initially we were hardly on the radar, but certainly later on there was a point when I would say hello to Richard and he would say hello back and be friendly, but if I'd said that to him now… In fact, James recently did a gig for Virgin and Richard came and did his drive-by "Hi, I'm Richard Branson" thing and completely blanked me (laughing), I was like, "Oh, ok great!"

**So, what are the challenges that you feel LCD Soundsystem has with this new album?**
Look, you are going out into a musical landscape where nobody really knows what the fuck is going on so there's the challenge right there. [LCD is] signed to EMI. And record companies like EMI are trying to reinvent themselves, to rapidly catch up with the public, which is refusing to buy or pay for music. And they have to figure out how they deal with that and how to resolve that. Can you resolve that? You've got the public and you've got the artist and the record company is in the middle. It used to be this tight fit and now it's not. So number one, really, is how you put the record out, how you make it interesting for an audience because the way you deliver the record is a very important. How can I put it…?

**You're gonna edit the fuck out of this right?**
Yeah.
Good.

**No, we're gonna have half an hour of just you.**
Oh my god! This interview's over! [joking].
How you deliver it [recorded music] to the world is very important. You look at role models, and what they've done. People point at Radiohead, but it's misleading. They have this enormous, worldwide fan base who is already built into the equation, a base that's going to want to have the expensive limited editions. So you can play around with things as they do, say, "Right, you can pay whatever you want for the records. A penny or ten bucks or 20 bucks, whatever you want…" They know they have this huge fan base that will want the really high-ticket item. And that's where they make their money. It's very shrewd, a good commercial and creative decision. Radiohead does this all the time. And they are very good at it. You have to respect it. We'll see what happens with U2… But the important thing in this equation is that an artist wants to get paid.

**You're job is to essentially manage James' time and to manage his intake of money. How has that changed from when you first started working with him to now? And where do you see it going in the future?**
In my own career: selling records was how you made money, that's how an artist made money. Now it's only one of the ways an artist makes money. It's not the primary source but it's still crucial. So one has to work with the record company, which is what I'm going to be doing with EMI with this record, to find the best way for them do their job properly. Because they want to do a great job and they want to sell loads of records. They want to make money, too. Remember they

have given us an advance against our royalties so they want to make that back and then some. So my job will be to work with them to try and find the least innocuous way for them to sell records without compromising the artist. Obviously for LCD, being on the road and touring is a major and important part of our income. As you know they are extremely good live—they are a very, very good, often astonishing and people know that. They have a tremendous reputation. This year we're going to light things up a lot, better production, raise the ante. That's important.

Publishing is important. I'm not really a great fan, nor is James, of people putting music in TV series for dramatic content, which is done a lot. There was one use that we recently turned down in a big TV series where they had this girl, drunk, passed out, lying on this couch and the boyfriend is looking down at her and they wanted to play "Time to Get Away." And I'm like, "That's so crap, so lazy." We passed, which caused us to get blacklisted by one particular big agency, as we were "difficult!" A blacklist is bad news but the idea of crassly using LCD music in those contexts I think is awful and horrible all around. James won't do it, he is super particular about that, and I agree even if it costs us. You see how a Martin Scorsese would use the Rolling Stones, which he does repeatedly. It's great. How many times can you hear "Gimme Shelter" in a Scorsese movie? It always seems to work. So, further answering your question, doing that is important, putting stuff in movies and video games. James really likes the video game world so he's always into that. The publishing end of things become key. At one time you could make a lot of money with sync fees [synchronization rights/usage fees for when music is set to moving picture]. Now it's not as much but still very important.

**What are the most wonderful things about dealing with James as his manager?**
Well he sends me money! That's the thing I look forward to the most I think [laughing]. James is great. I got involved with James because I loved LCD's music and I knew him a bit and really liked him. I also had respect for what he was doing. He's an articulate, canny, intelligent guy. He's one of those intuitive, visionary artists. I don't mean that in an overblown sense, but that's what he is. I think everybody that works with him will agree to that. He can also be a tremendous pain in the arse mind

you, but you take the rough with the smooth, you know [laughs].

**And how did the connection and becoming LCD's manager happen?**
James was working with another manager and they parted company and he needed somebody to help him out. Three years later here we are.

**So that was between their first and second albums?**
Correct, yes. It was at just the beginning of the cycle for the second record.

**In terms of recording, here at the mansion, what do you find rare or striking about the setup and the situation?**
I think the fact that two weeks ago [the main living room] was just a big empty room, with no gear in it or anything like that, and the fact that James has magicked this stuff, sending it from New York, hiring it here, begging, borrowing, and stealing equipment from people, pulling it together, patching it together, creating this kind of very unique studio—I think that kind of energy and excitement and trauma informs the music. Because this is a onetime thing, I think the music is going to have that quality. It will have the quality of spontaneity. Because this is the way this is put together, it's very spontaneous. Normally, James would have gone to a studio he'd been to before or he knows…or his own studio, Plantain, the DFA studio. So the idea that you kind of "bravely go" I think is great. However, I've no idea how we ended up making this record in the most difficult and expensive way imaginable. But you know, I think somehow it's the right way.

**What are the biggest expenses?**
Oh, shipping the gear from New York. Hiring the place, which is not cheap. Bringing people out. Airfares, cars, per diems, food, all of that. If we were making this in New York, with most of the people involved you are just talking about a Yellow Cab ride, period.

**What's the feeling you get from being in this space?**
I've never been in this space before; this is my first time. I just think it is a very original, very interesting space. Rather than being in a padded-cell studio somewhere, we're in this big, old, rather dirty and dusty mansion in Laurel Canyon.

**You've worked with a ton of bands.**
**Are there any bands that LCD Soundsystem reminds you of?**

You know, the really great thing for me is that the songs are extremely original. James always surprises me—its always different. Yeah, there are references that you can make and that people do, like to Talking Heads or Brian Eno. James has very strong musical influences. With this record [*This Is Happening*] there may very well be those influences, but they are just occasional colors and hues and not the substance of the music. So yes, I think having a good, solid, and extensive musical background would probably make you appreciate LCD more. Although, when those words came out my mouth I don't think they are particularly right. LCD are a special band.

**In terms of being a manager, has it been difficult as a relatively new career move?**
Yeah, totally, I've always been on the other side of the fence, the record company guy, not the management guy. In fact when I started managing, I think I made some mistakes because I was thinking with my record company hat rather than my management hat. And then there was a rather schizophrenic stage of wearing two hats which didn't look too attractive.

**What were some of the mistakes you made?**
Oh, I can't remember and I'm not going tell you anyway!

**What are some of the best decisions you've made as a manager for LCD?**
The really good ones you mean? Oh man, there's just too many to mention. Hundreds, probably thousands of fantastic ideas, decisions! You know the best decision I made for LCD? It's been staying out of the way of James, giving and creating space for him to do what he does. He makes great decisions, and whereas I don't always agree, he has been proved right on so many occasions I have learned to trust his instincts. When I was working as an A&R man I always felt my job was to stay out of the way most of the time. It's the band's name on the record, not yours. Create an environment for them to do their thing. This is James' show and my job is to basically help him to deliver his vision.

**Where do you see James in five years and where do you see LCD Soundsystem in five years?**
You know, it's very, very hard to say that, I mean I think, the next couple of years have to be seen in terms of this record. But what will happen in the musical landscape? Are bands going to be bands? Does James want to tour anymore? Touring is incredibly wearing and difficult, even when it's done carefully and well. I don't know. I mean I really honestly don't know. James is a very talented person. He's going to have a career no matter what. But outside LCD I don't know, maybe he'll start seriously composing, scoring movies or writing screenplays or something. He's a very talented writer; he may go into that. There may be an LCD Mark IV in five years' time—all is possible.

**James has talked to me about how the money's fluctuated with remixes. How has that changed the landscape of remixing and how has modern technology changed the role of a remixer?**
Well, you know, because things are digital a lot of people think that they can remix things themselves and don't need outside help. There's a lot of that; they don't look for the expertise or a new pair of eyes and ears coming into the situation, which is, after all, the point. But you know, James works with analog equipment, old equipment. His sonic sense is very intuitive and he's not necessarily going use Pro Tools and all these other toys to do mixes, which is unique.

**How has remixing changed basically? Why did people get paid that much more before?**
Simply: record companies had more money because they were selling tons of records. People weren't able to go and get the record for nothing so there was more money involved in the equation. And a remix could be a very important tool in the arsenal of realizing the potential of a record. But now companies don't have the budgets to spend on things like that anymore.

**So when James decides to do a remix, as his manager, what do you feel allows him creatively to indulge in that experience?**
It totally depends on the music and how he responds to it. You know it depends on what the song is, if it's something he really wants to do or he's got a really good feeling or immediately thinks of a way into it. Sometimes, I'll be honest, there's the question of it being a good size check which is gonna pay a bunch of bills, that's important.

**What are some of your favorite LCD songs?**
From the last album I absolutely adore "All My Friends."

**Why?**
I think lyrically it's very interesting and really strikes a cord, and I think it's a very truthful song and hits on an experience we all feel about friends and loss and everything. "Someone Great," is a huge audience favorite and a close second to "All My Friends" personally.

# MATT THORNLEY

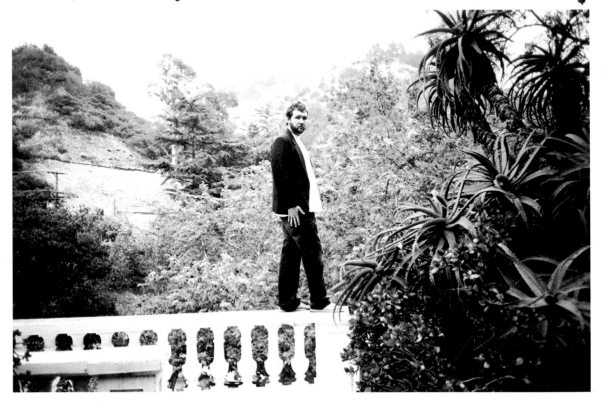

**What are you doing for LCD?**
I'm working here with James as his technical
assistant, engineer, production manager some
would say. I work with James on the live aspects
as well, but this time I've been pulled in to help
throughout the recordings.

**How long have you been working with James?**
I've been working with James since 2005, so four
years. Since the tour for the first record that he
did. I was initially here as an intern at DFA Records'
studios, helping James and his former assistant,
Eric, record mixes and add finishing touches to
various LCD projects. Their front of house sound
person couldn't make it for the first three weeks
of the US tour and he needed someone to fill
in. I had done front of house sound and sound
engineering before, back in the UK, so he asked
me to fill in for him.  Their sound guy came back
on the tour and I then did technical support for
them and The Juan MacLean, who was touring as a
support band on that tour.

**What did it take to put this whole studio together?**
It took the ability to crush three months planning
into a week. This is just a house—it's not a studio.
People record here, but basically we had to move
the studio from New York all the way across the
country, which involved finding a way to ship it,
cataloging everything we had, giving the list to
James. Some of this stuff is rare and irreplaceable,
so it takes a lot to get it here safely and in one
piece. A lot of these things didn't have cases, so
we had to figure out casing solutions, shipment
solutions, packing solutions. Once those priority
devices got here we needed to unwrap them and
get it all working in a space that we knew nothing
about. Then we had to get the acoustics technically
correct, make sure the cables were good to go.
Noise has been a problem with the house.

**Were you able to talk to Rick Rubin, the owner of
this space who has recorded many albums here?**
No, not personally, I'm not sure who actually
sorted that out. Nobody talks to Rick, but I'm sure

James dealt with somebody about what the space was like before he moved in. There are a lot of big records that have been made down here, so it is without a doubt usable. A lot of hardcore and metal bands work here these days—System of a Down, Slipknot. The Chili Peppers recorded some big stuff here back in the late-80s/early-90s. It has a big sound and this [living] room is apparently great for recording big rock drums, but that's not how we work. We switched it around and put the drums were they usually have the control room. We switched it up because it's way deader, smaller, and tighter—much better for the disco drum sound we go for.

**What are some of the challenges you see with making this album?**
I don't know, I mean I think we narrowed down most of the problems that I could foresee, which is getting the drums sounding the way James needs them to sound, getting things running in an aesthetically pleasing way for James; you know, things have to be in the right place and accessible, ready for him to just work when he needs to. We kind of finished it up last week when we got a new computer workstation for him based at the piano in his bedroom. This way he can control things from wherever he's recording, which gives him a lot more freedom. As far as problems with the rest of the recording, I don't know. It's down to James and his creativity and his work schedule, really. We are here for a lot longer than previous album sessions. Normally, it's four weeks broken into a couple of two-week blocks, whereas this is a complete three-month block.

**Why do you think James decided to come to LA and not go to Texas or France or London?**
I don't know, he likes LA, he gets a good vibe here you know. His initial feeling was he needed to find somewhere that was able to house whoever was gonna be here from the band recording—accommodations for maybe five or six people was his initial thought. Actual recording studios are not set up for that. Most of them are just a computer and a vocal booth. Some of them have live rooms but no accommodations, so it's tricky. It's weird to come out here, but since LA is known for being a place to escape to and confine yourself away and work on stuff, I guess it was the vibe he was looking for. He wanted to make a weird LA record you know—old school. There are no distractions here that you would get from being in the office at the label, and whatever else happens in his regular daily routine. Everything here is contributing towards the vibe, his feel of making the record. It's weird. We're all dressed in white and shit.

**How is the scene in LA? Is there a social aspect to being here?**
Last night was a little crazy. Missy, our resident chef, DJ-ed out for a friend's birthday, which was a lot of fun. We ended up going to some other party, and we couldn't figure out what it was for or about, but it wasn't terribly crowded even though it was a huge crazy place. It turned out to be the funeral home of a cemetery—a converted room with a stage and weird gothic décor. There was a lot of free booze, lots of free food, which is always good. James' personal assistant, Matt Cash, DJ-ed as well. We went out the other night to The 3 Clubs. It seemed to be a very young crowd there—more so than where I'm used to going in New York. Anyway, I don't really know the scene here, but I'm trying to get a grip on it.

**How does getting away from New York affect you?**
I'm used to being away because I tour with James a lot. We haven't toured for a while, but I work with other people, too, and I'm used to being away for chunks of time. But I've not really been away for a while—it's been seven months or so since I've been on the road—and I've been working on stuff in New York, so it's been good getting away, it's been different. It's difficult because I'm married and it's difficult with the wife, but I guess I'm gonna be here for two months unless anything comes up at the studio in New York.

**What did you think when James first proposed this idea to you?**
Initially I was only supposed to come and help set up the technical side of it and then go away and come back later and break it all down. But after being here for the first week, he seemed to rely on me for a lot of things he didn't think he would, so I was kind of pulled in to help throughout, which is great. I mean I can't complain really: living in a mansion, sunny weather, a pool, a good location. I'm feeling good, you know. I think it's good for getting work done, too. We've got a lot of time to work.

**So does James make you wear white?**
Yeah, we have to wear white otherwise it gets very painful.

**James Murphy:** You're lying.

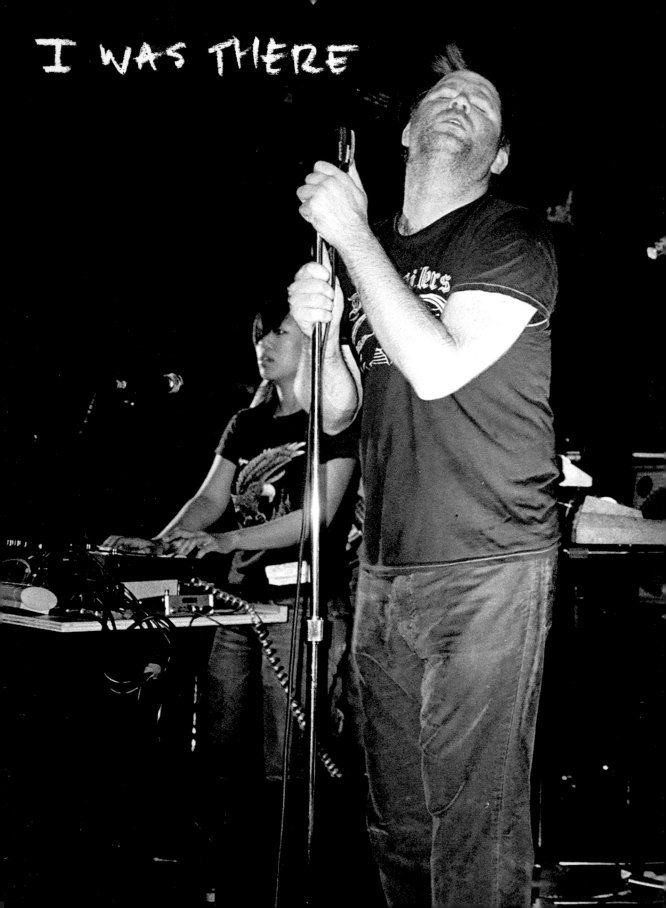

I WAS THERE

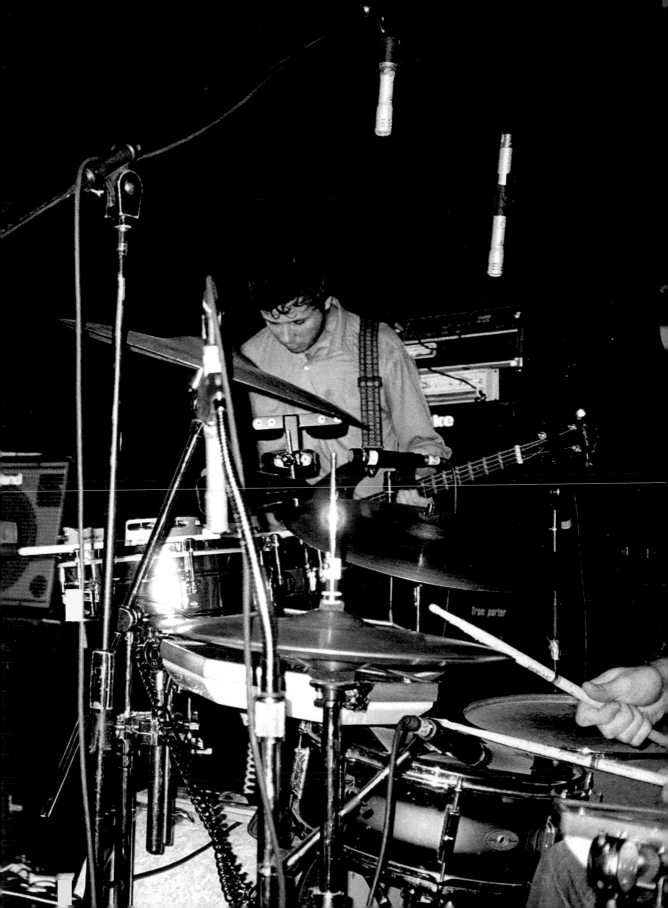

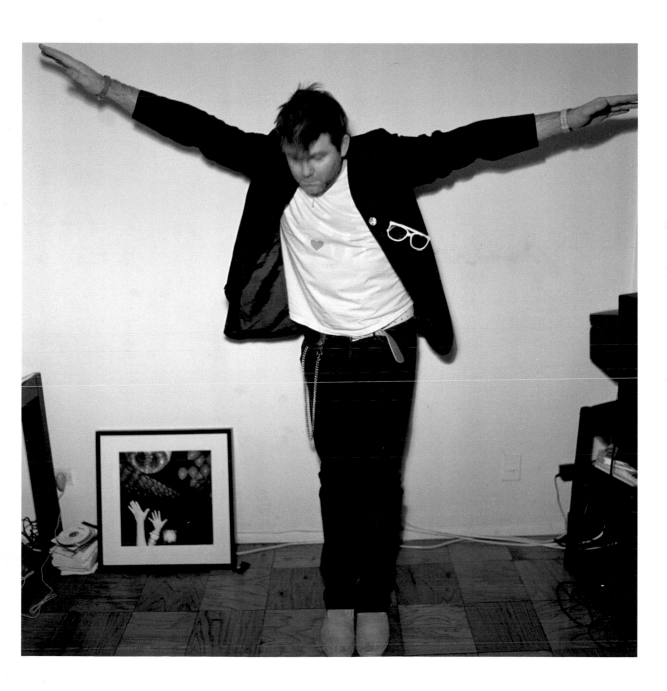

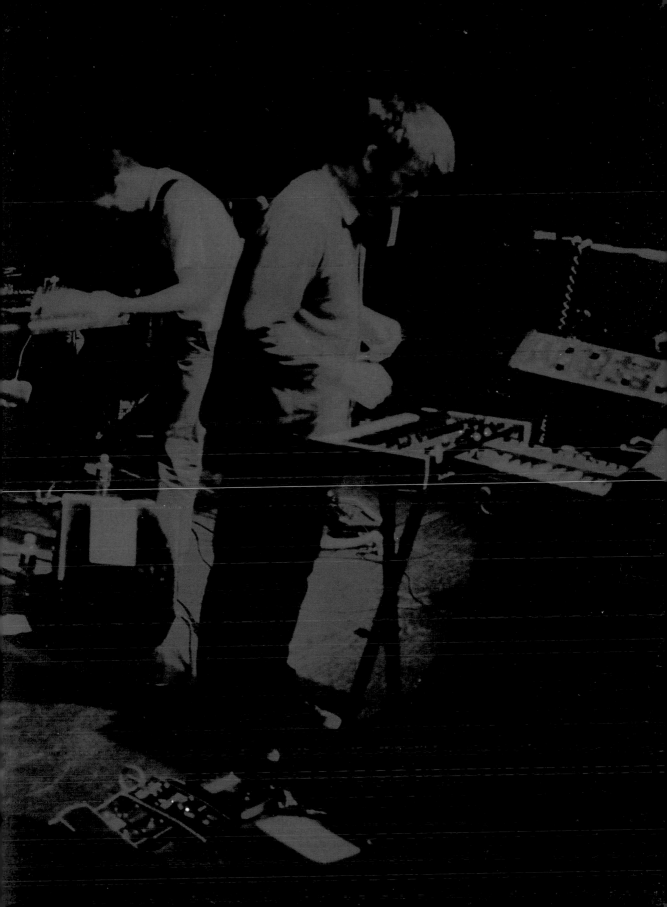

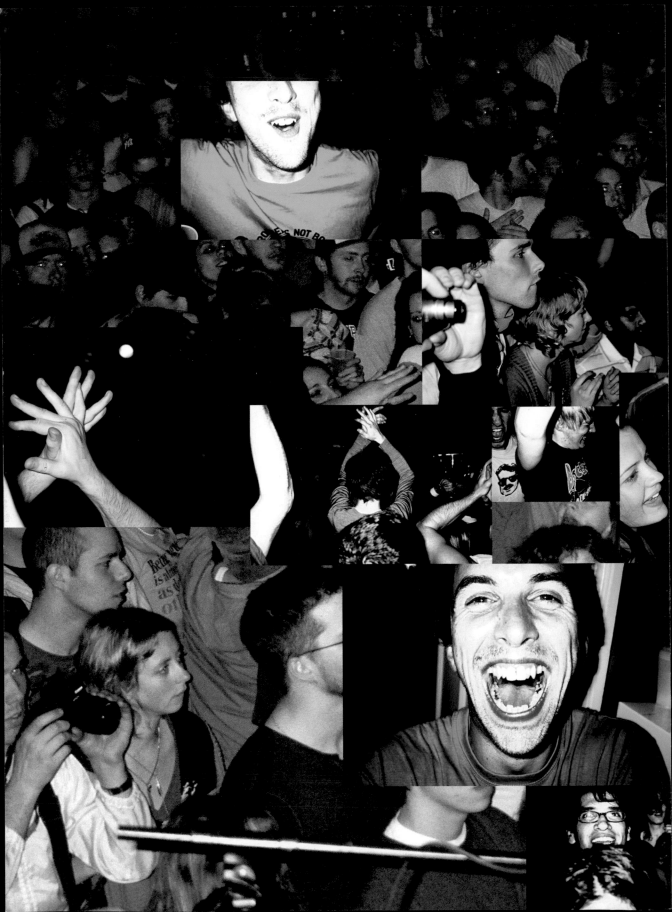

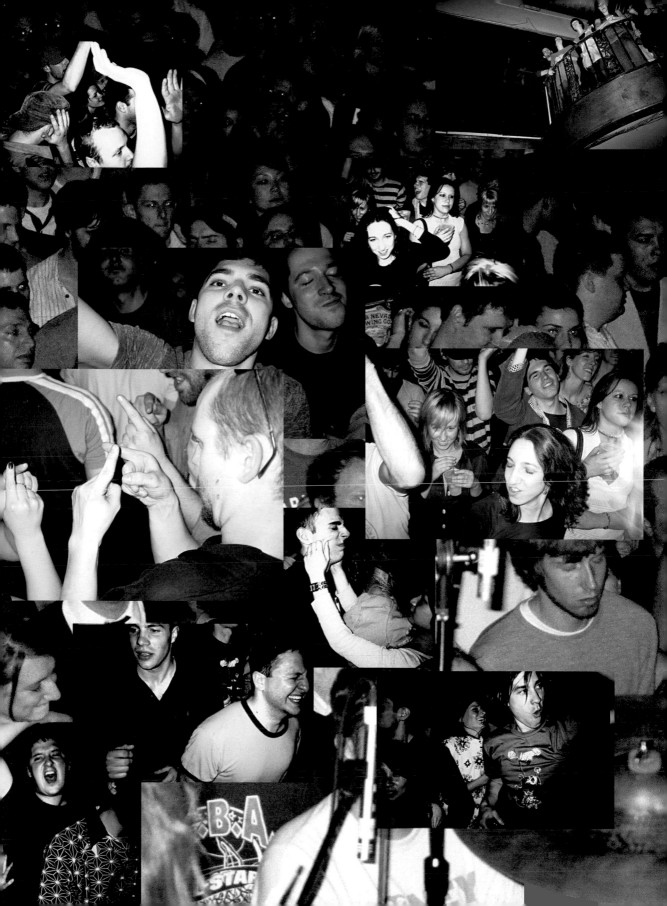

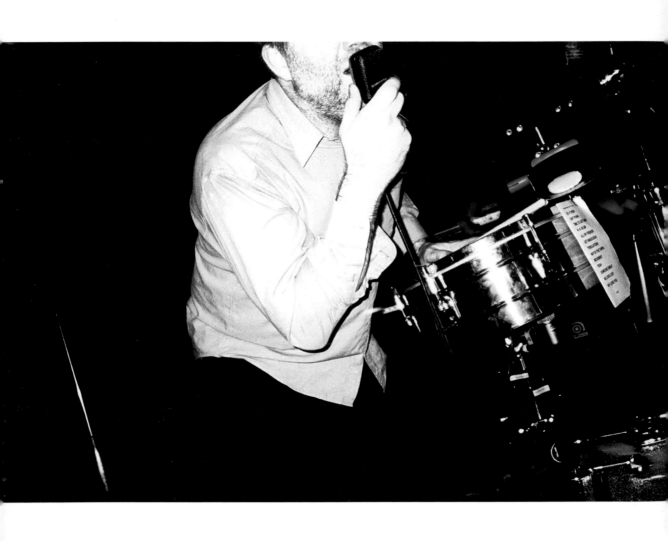

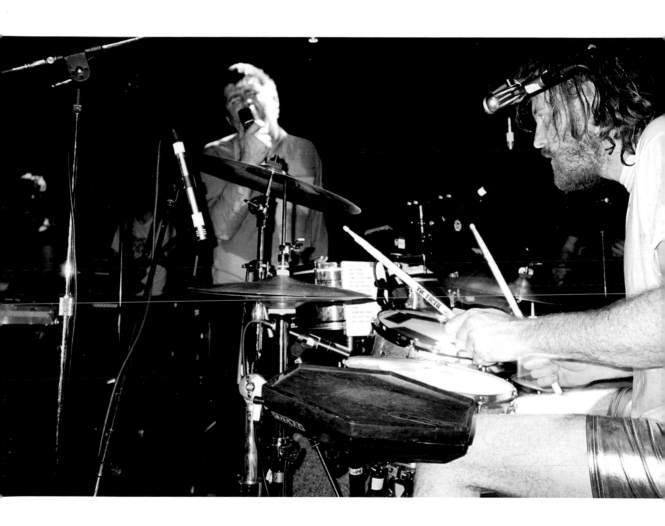

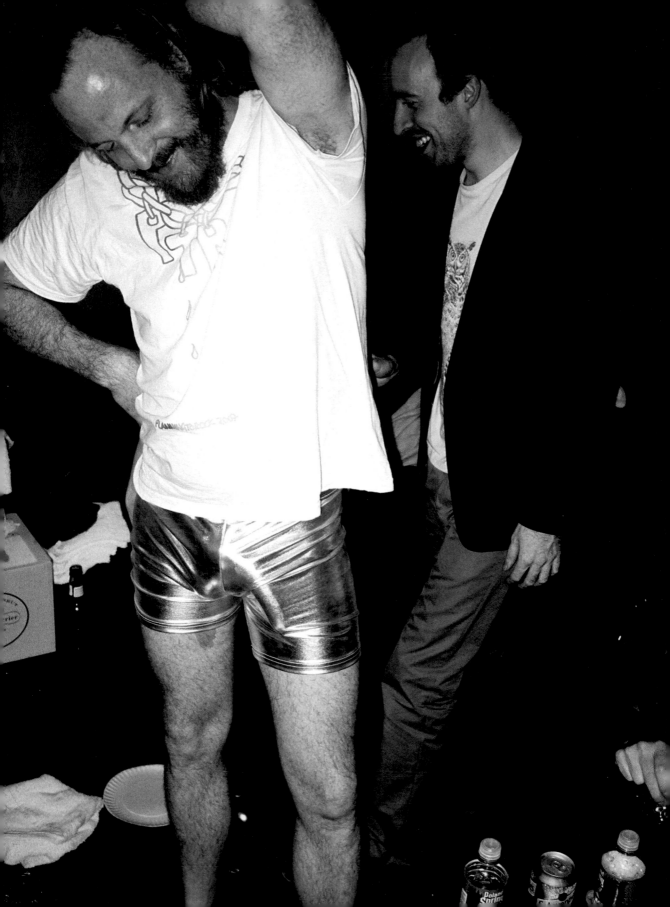

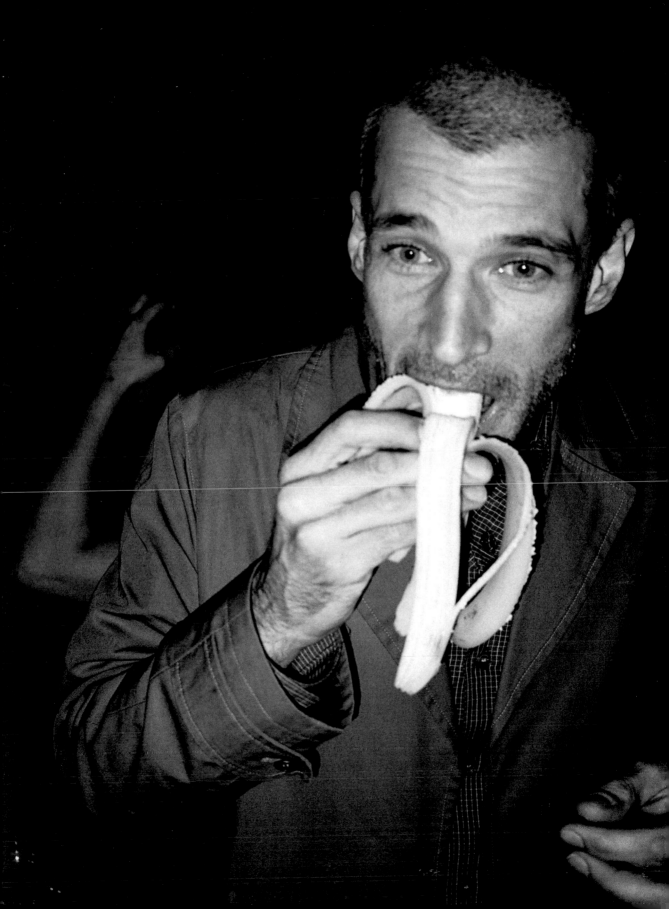

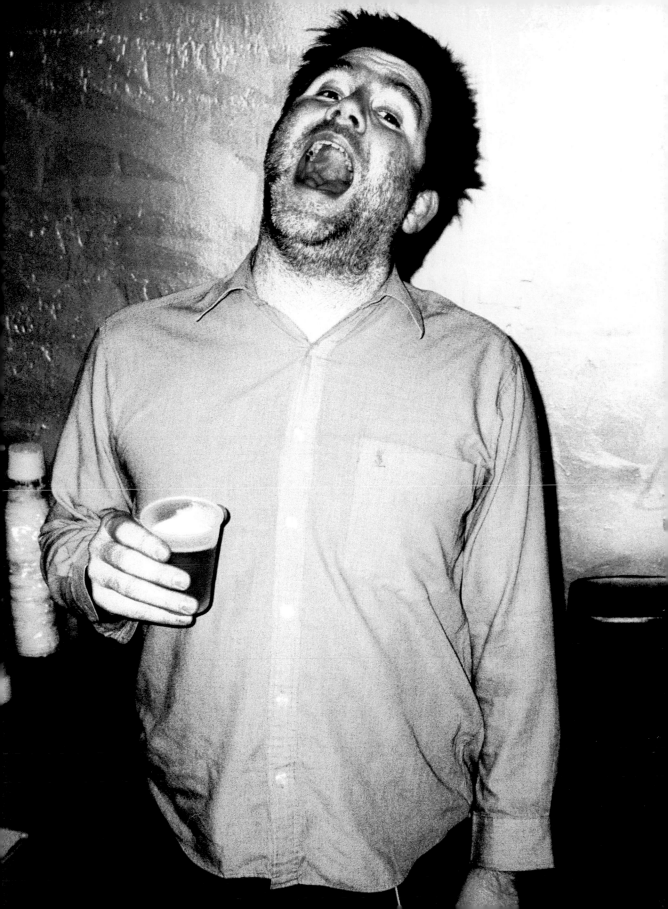

CAM-STATUS: STANDBY F

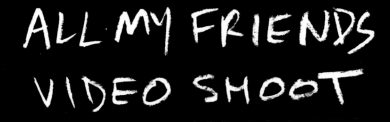
ALL MY FRIENDS
VIDEO SHOOT

fps    285 ft

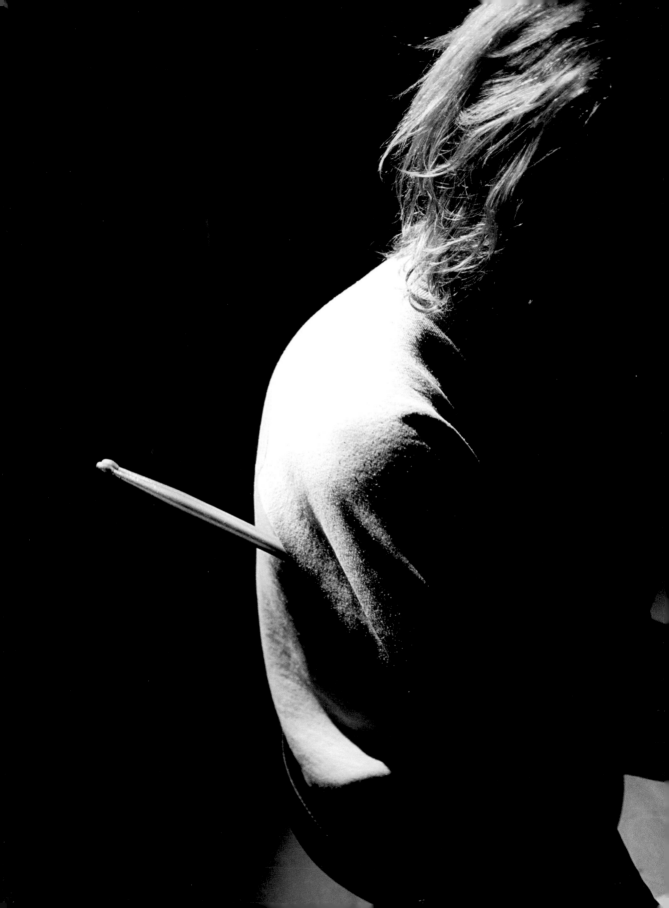

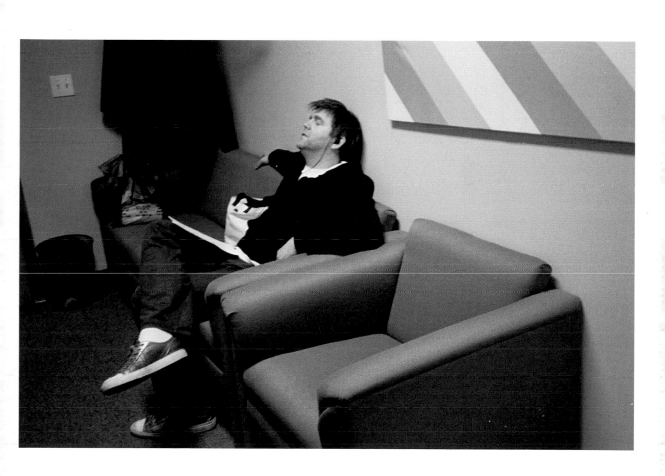

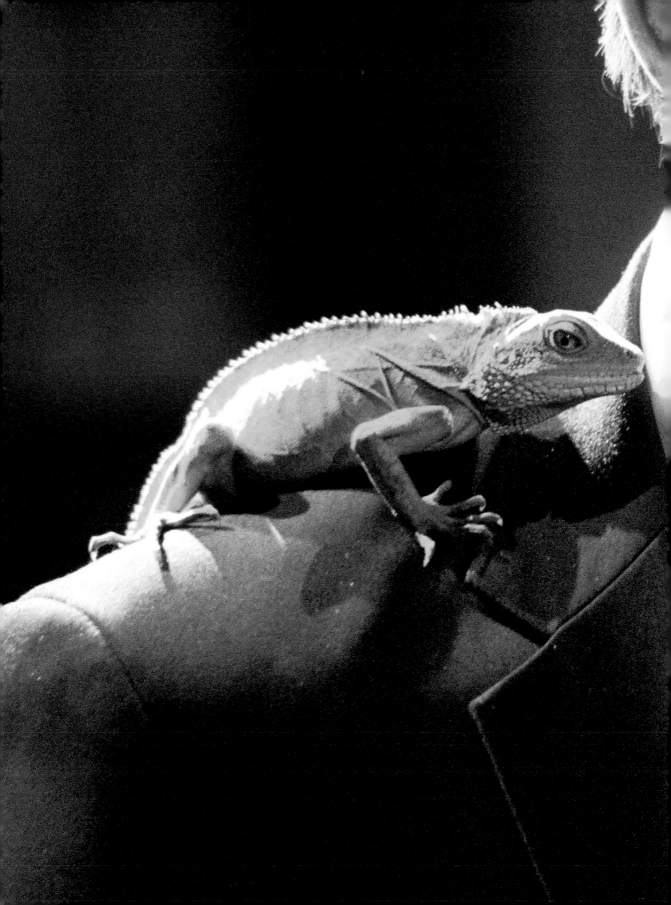

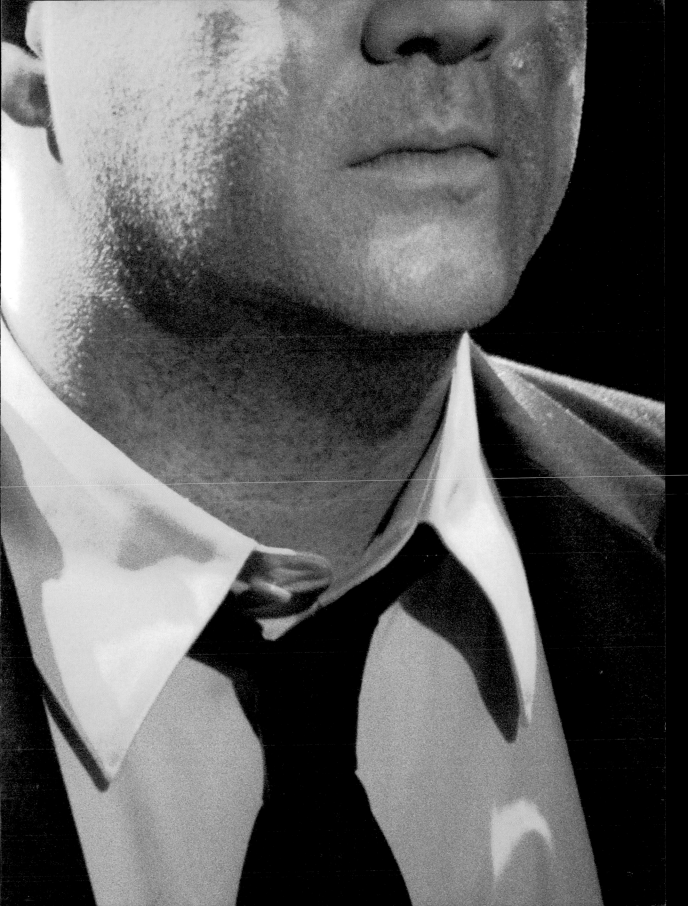

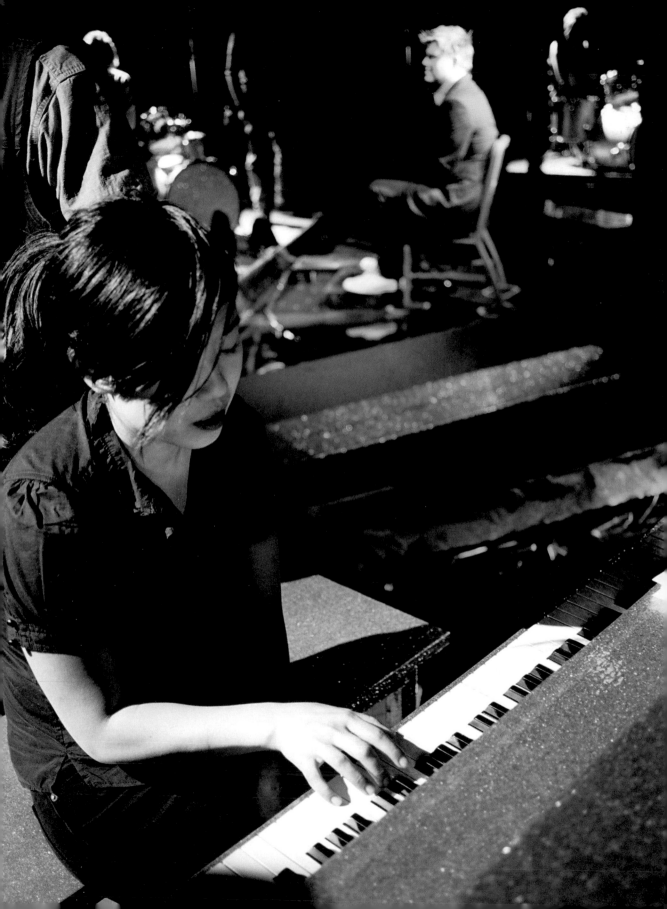

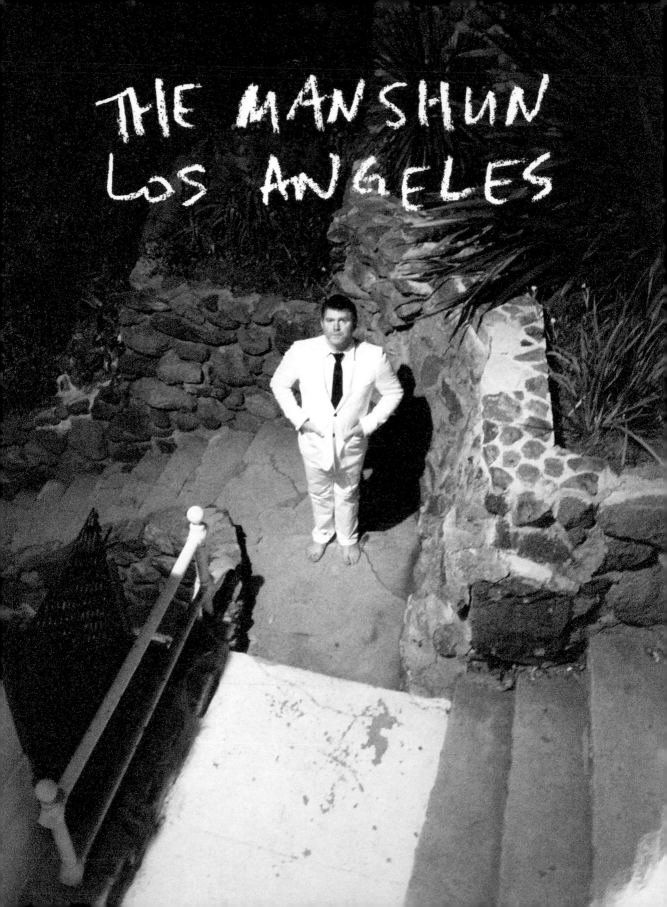

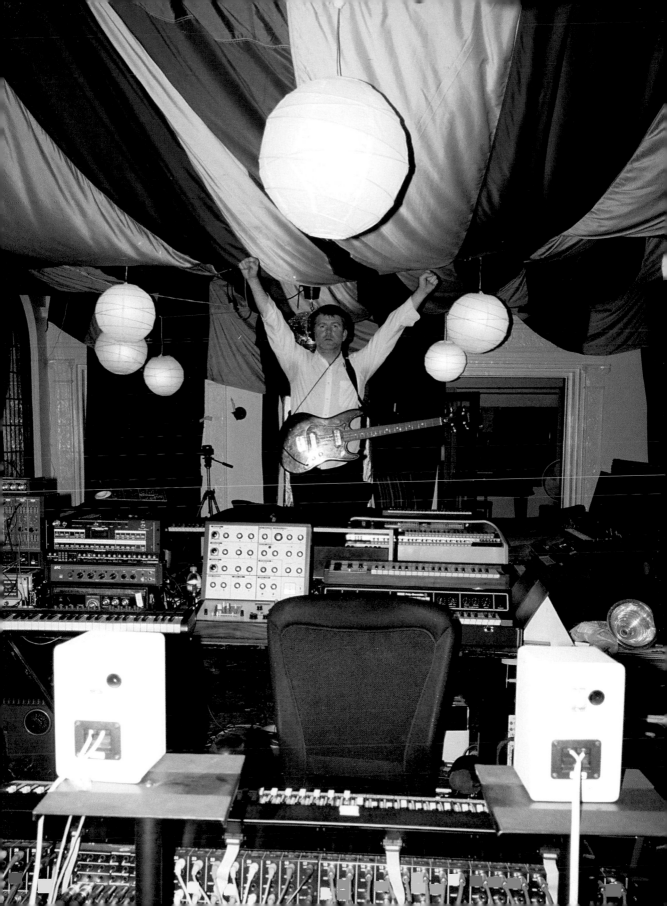

Just a note of great appreciation for all you are doing for Gunner. We are so grateful that he is being cared for and learning so much from you. This is the best thing that you are giving Gunner, a chance to learn and be taught by an awesome musician but even better (according to Gunner) an awesome person.

...success and ...again Thank you for everything Just a little something to enjoy in your spare time Mark

The Bjork Family
Scott
Julie
Chelsea
and
Garth

MISSY
Patopat, Ruven, Gumboe
-Your sleeping off your hangovers while were on our way to the aiport now But however severe the hangover is today it has to be worth the sweet ass night last night That was amazing, like the Rest of the week with you guys. Thanks for the

Gary
823-2...
Piero

SATISFACTION
SHIT DONE

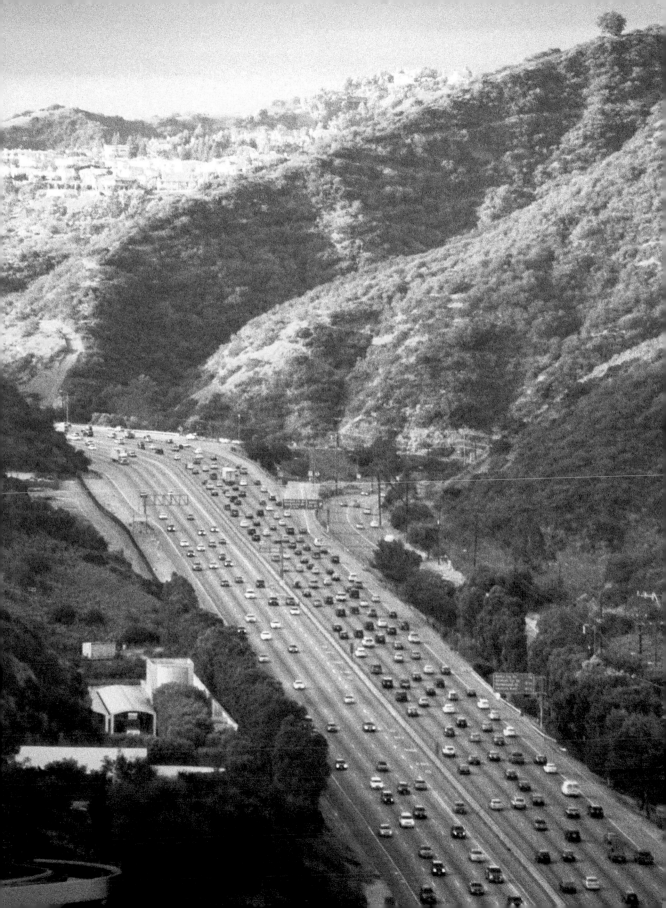

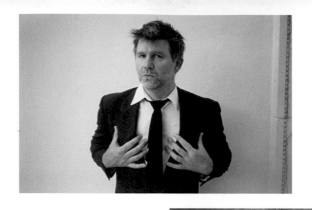

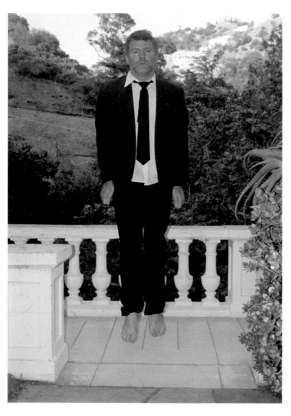
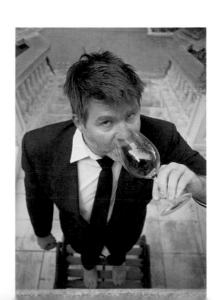

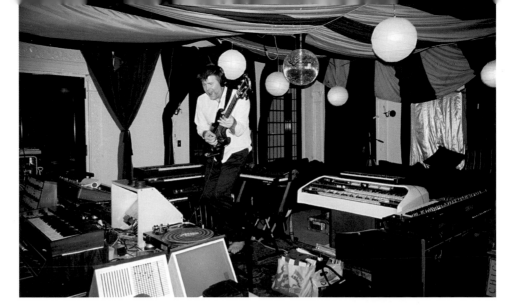

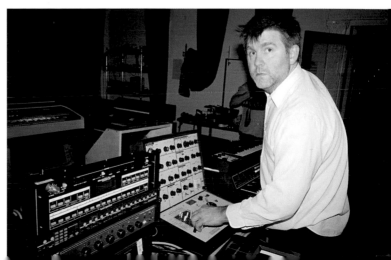

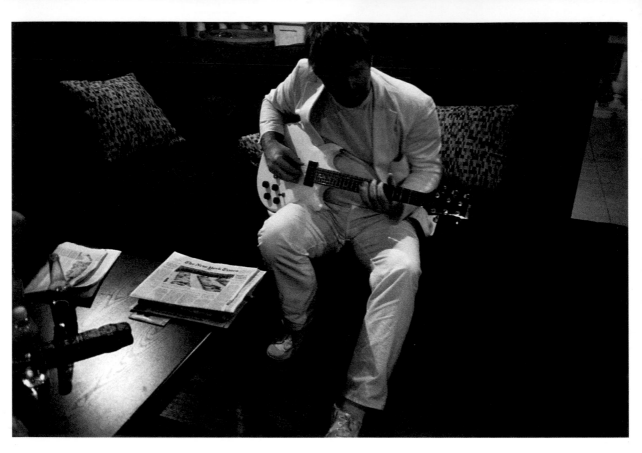

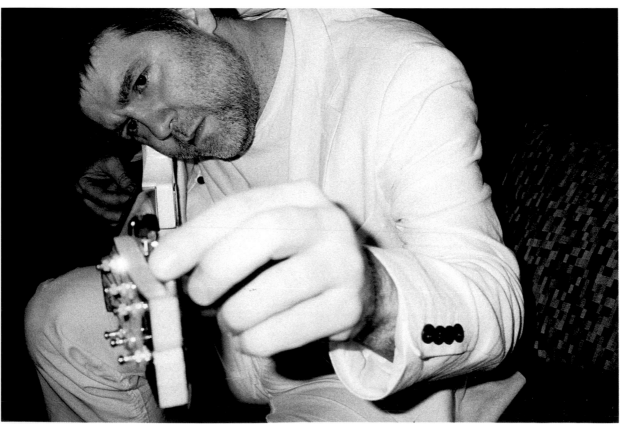

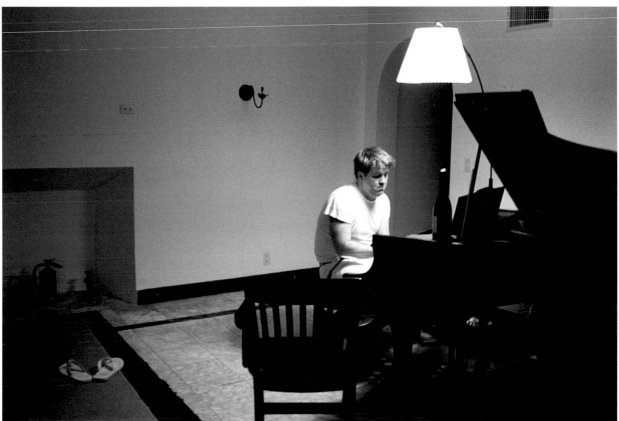

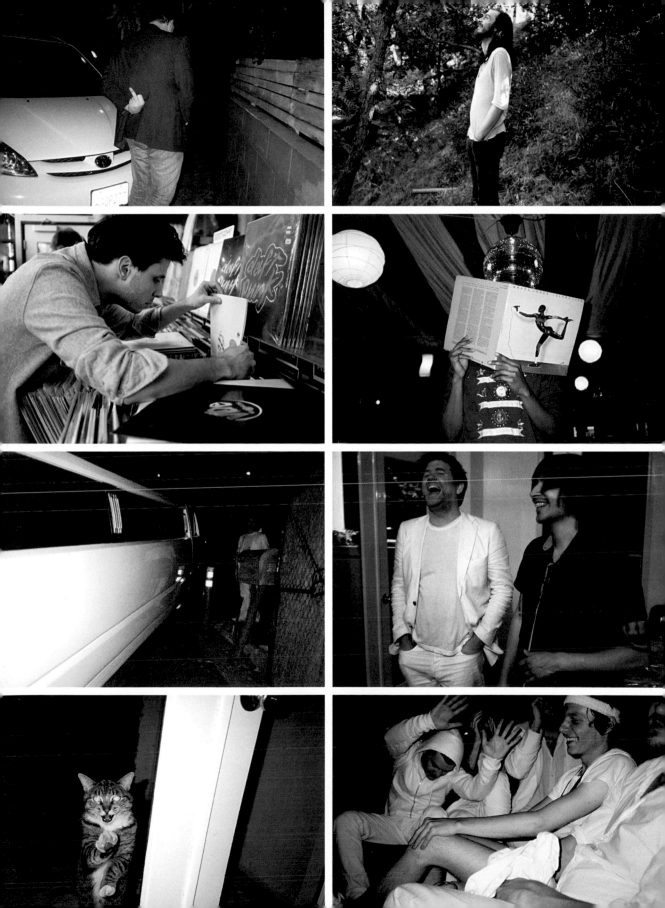

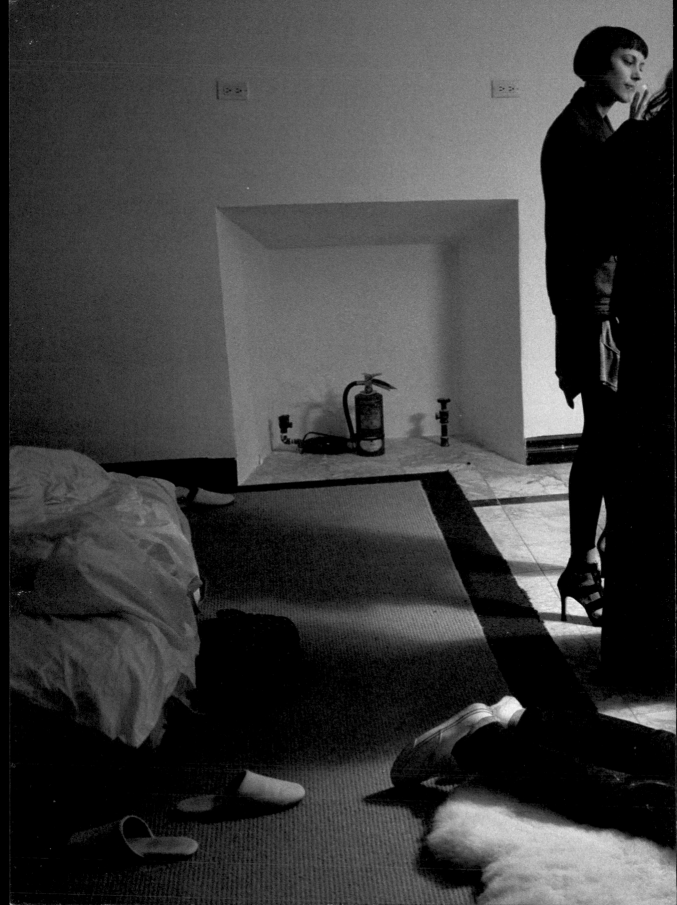

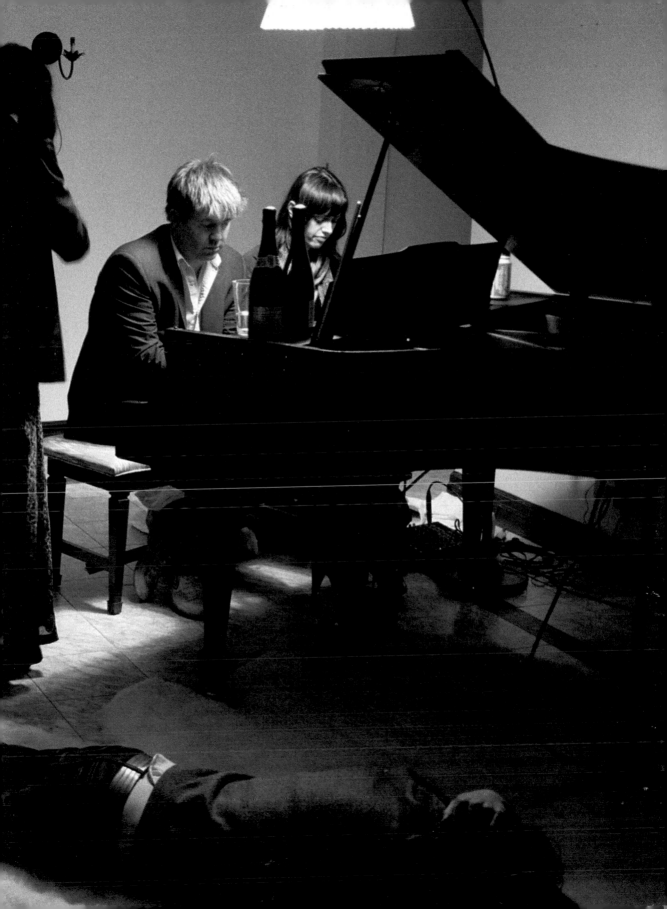

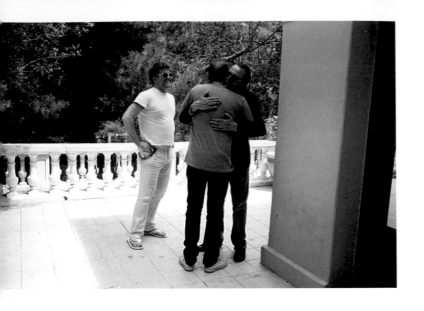
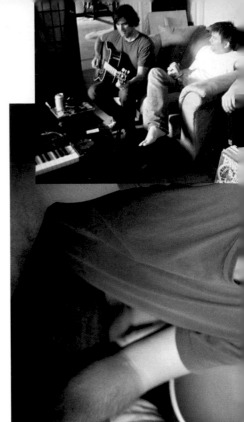
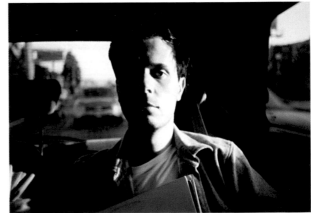
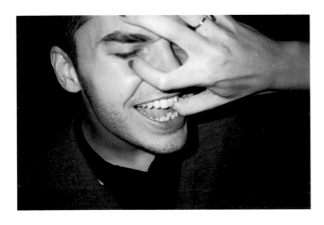
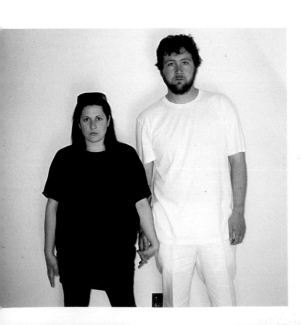
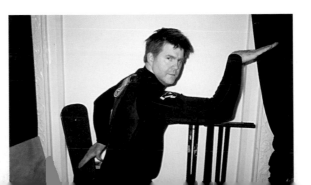

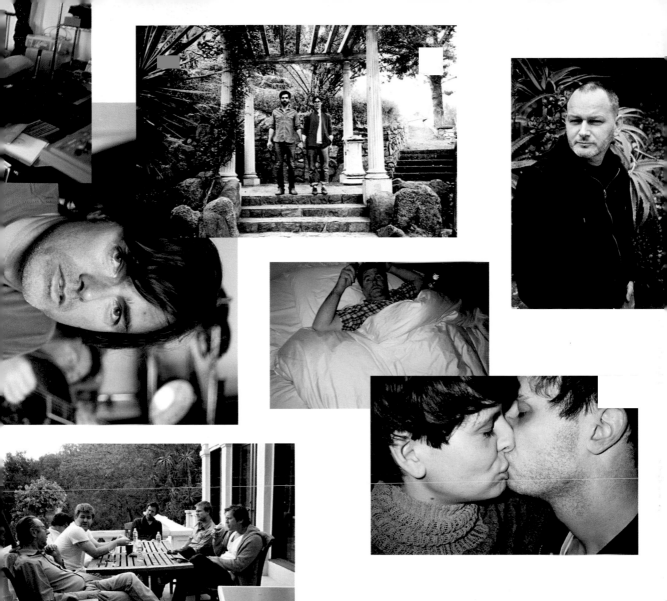
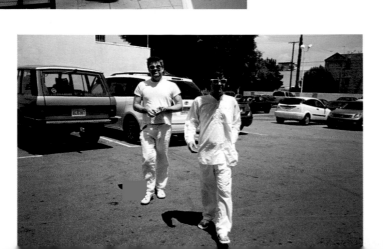
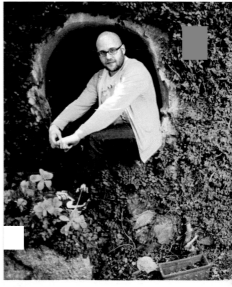

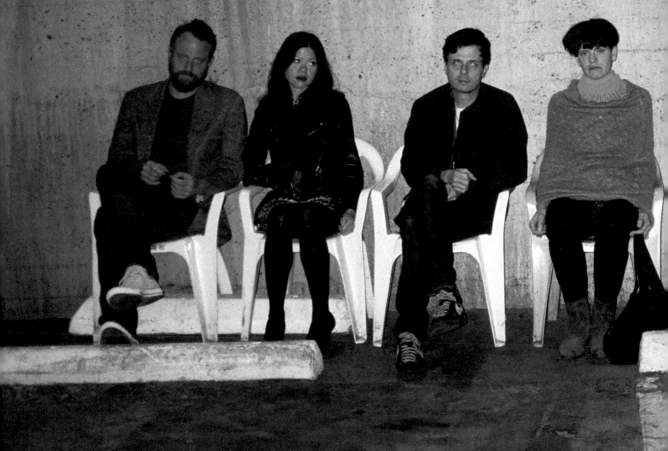

SATURDAY NIGHT CREW

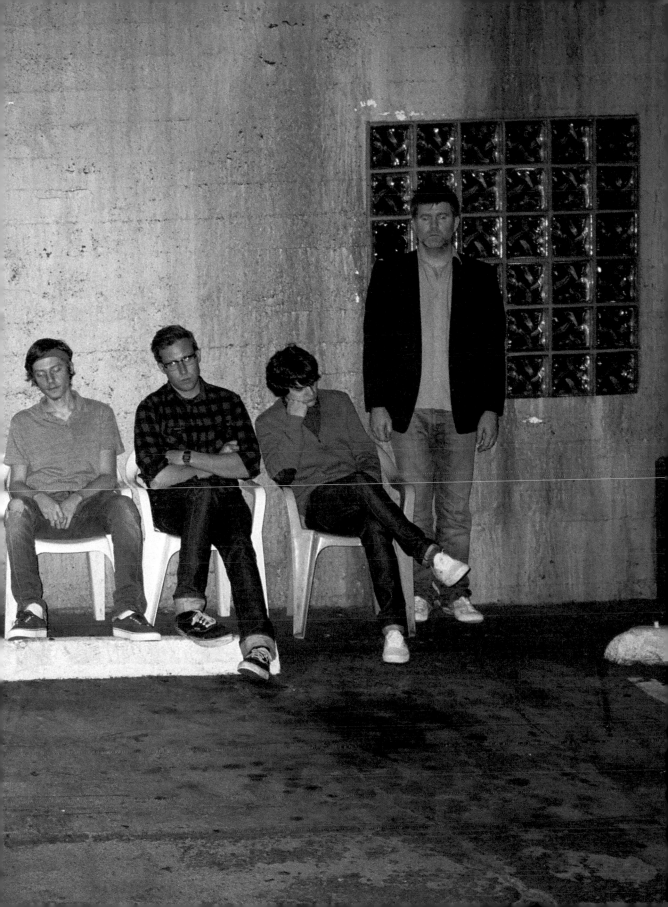

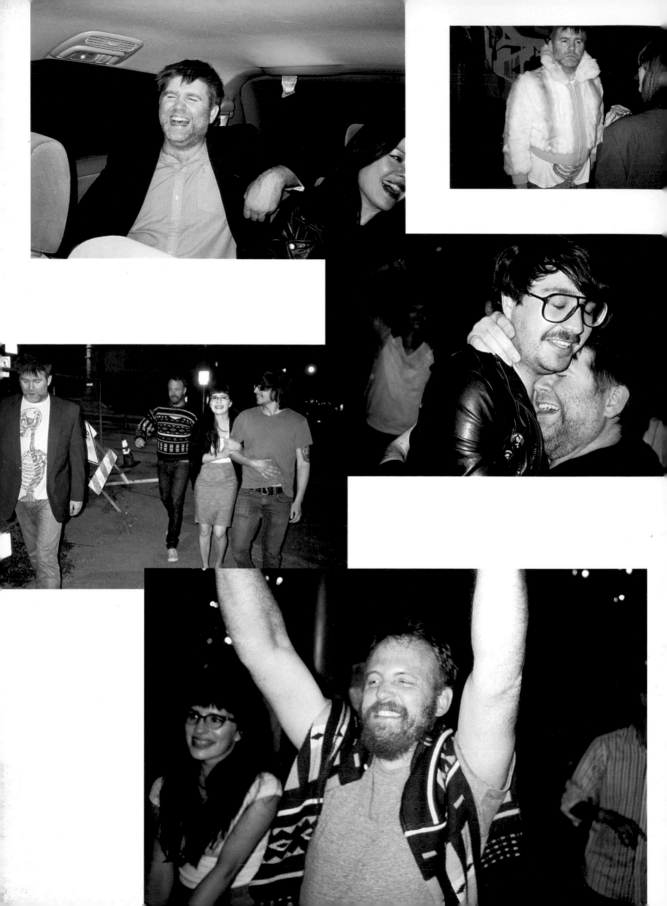

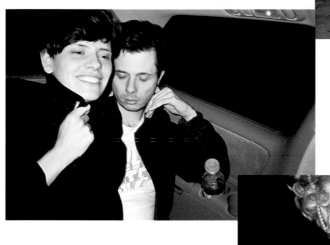
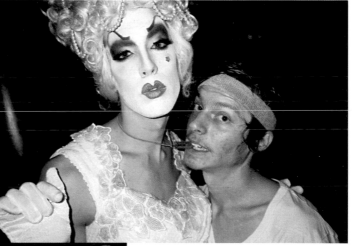
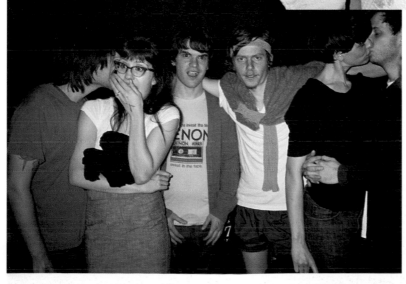

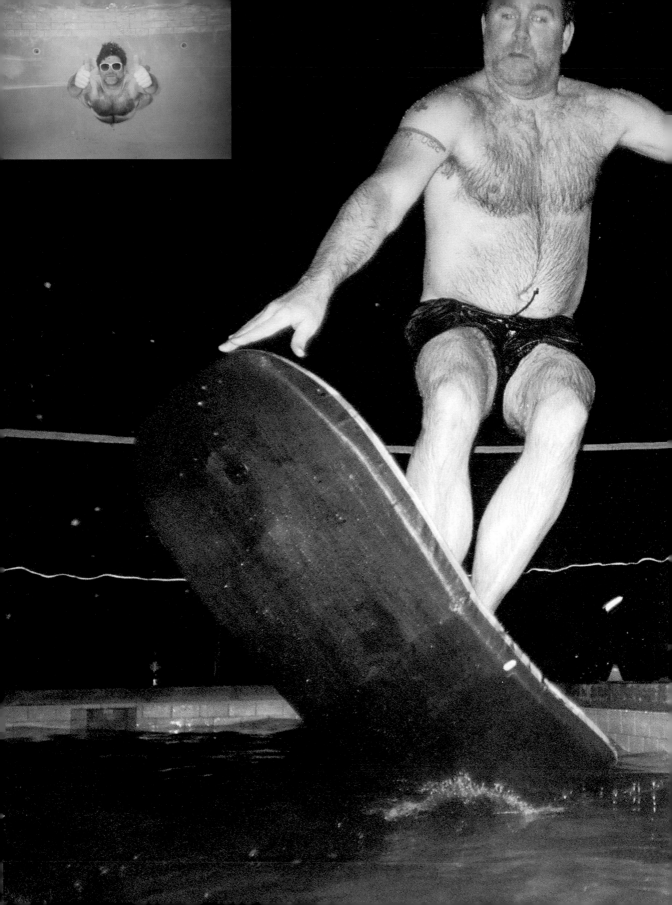

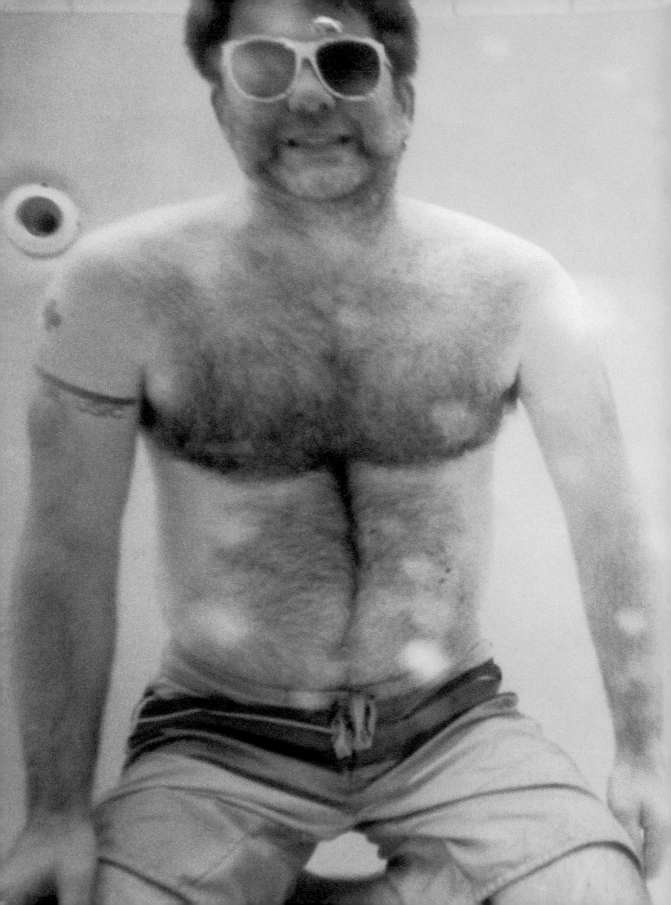

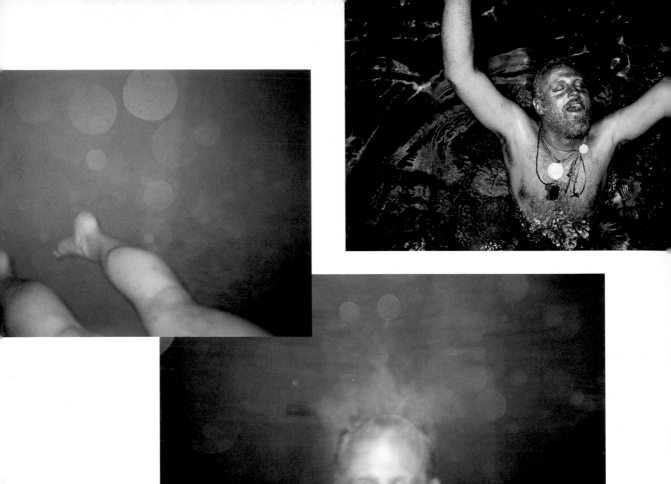
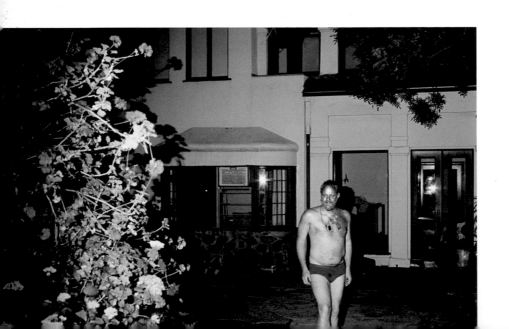

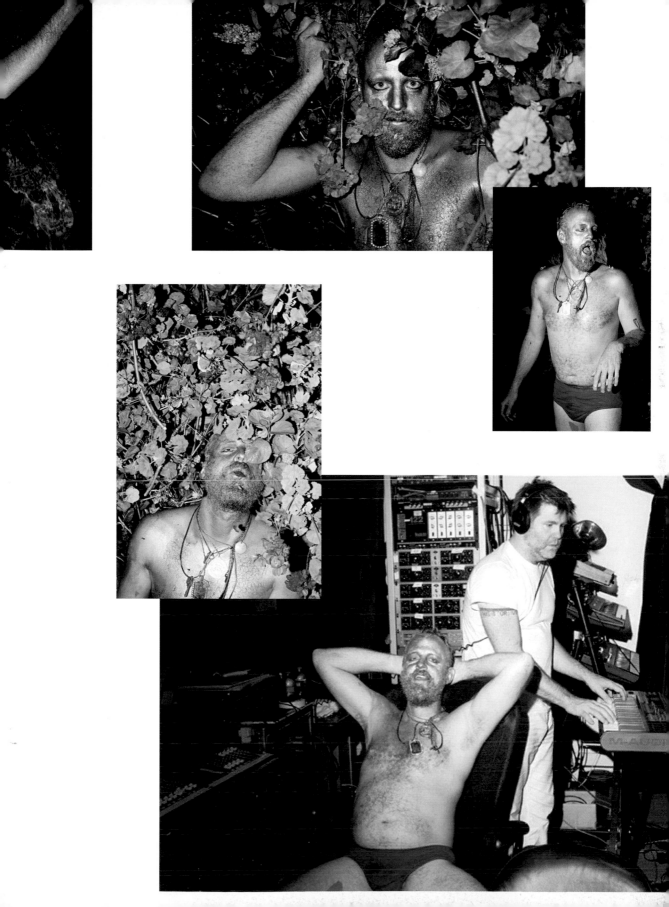

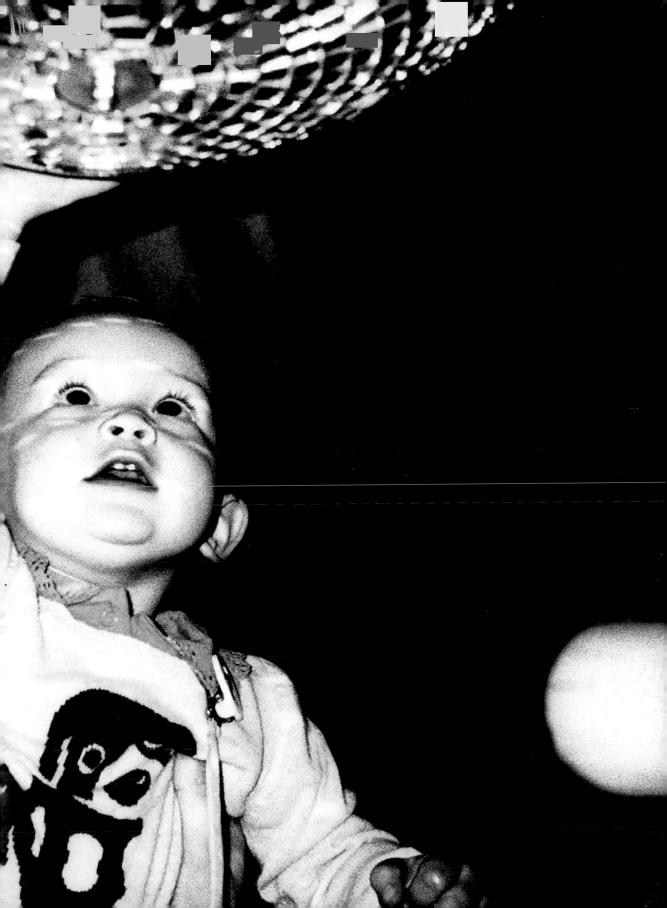

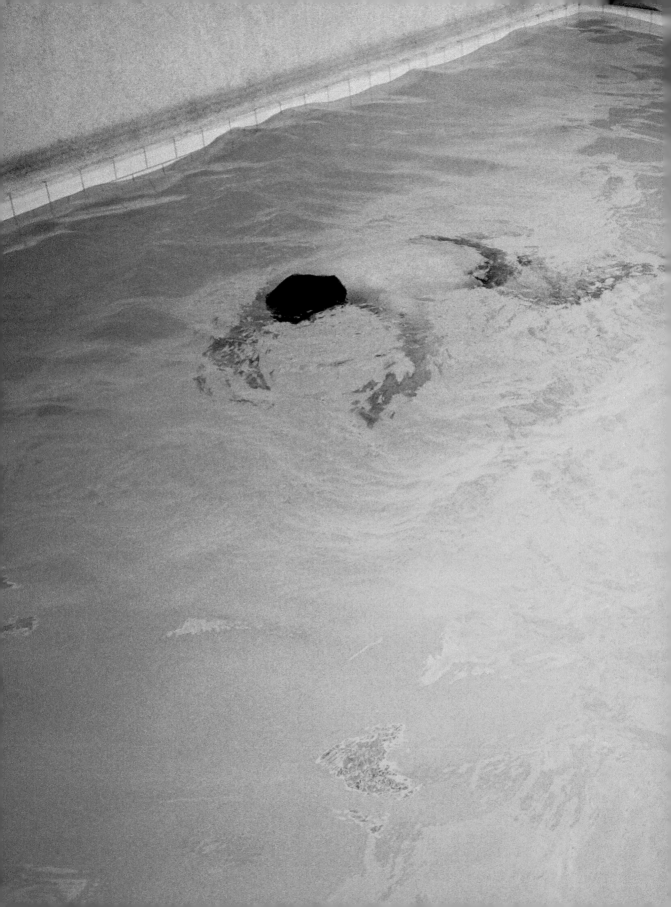

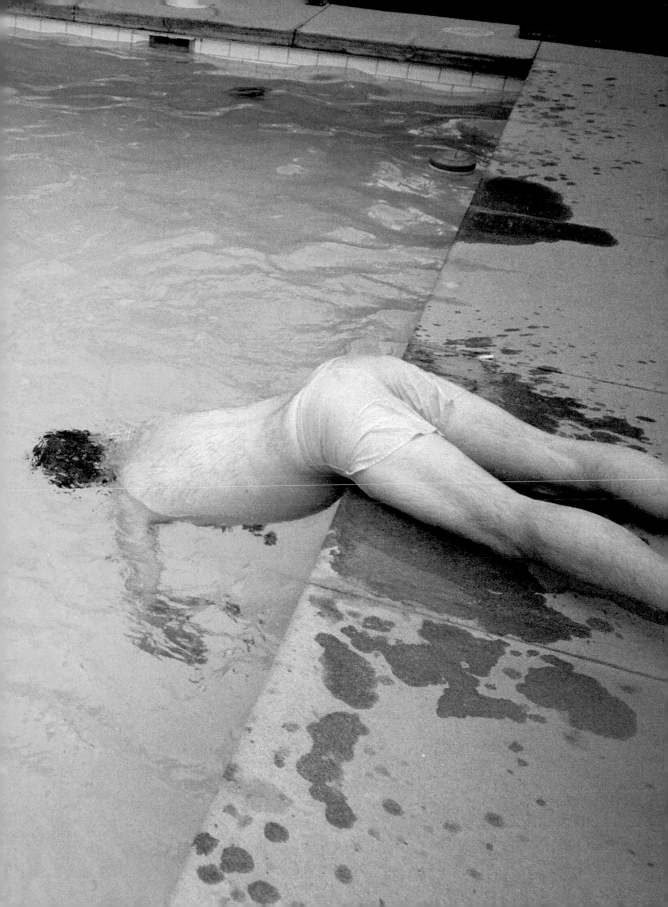

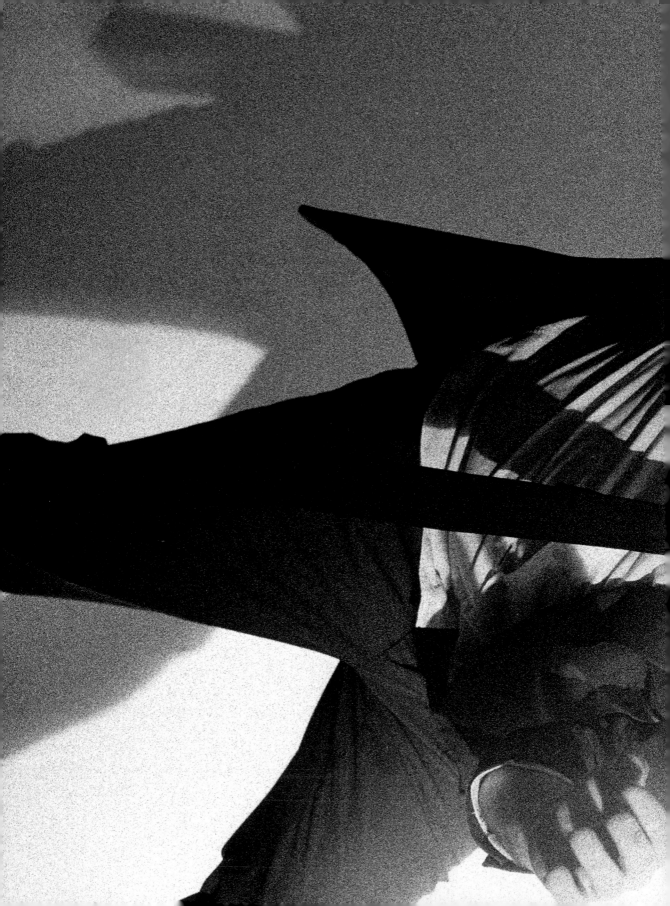

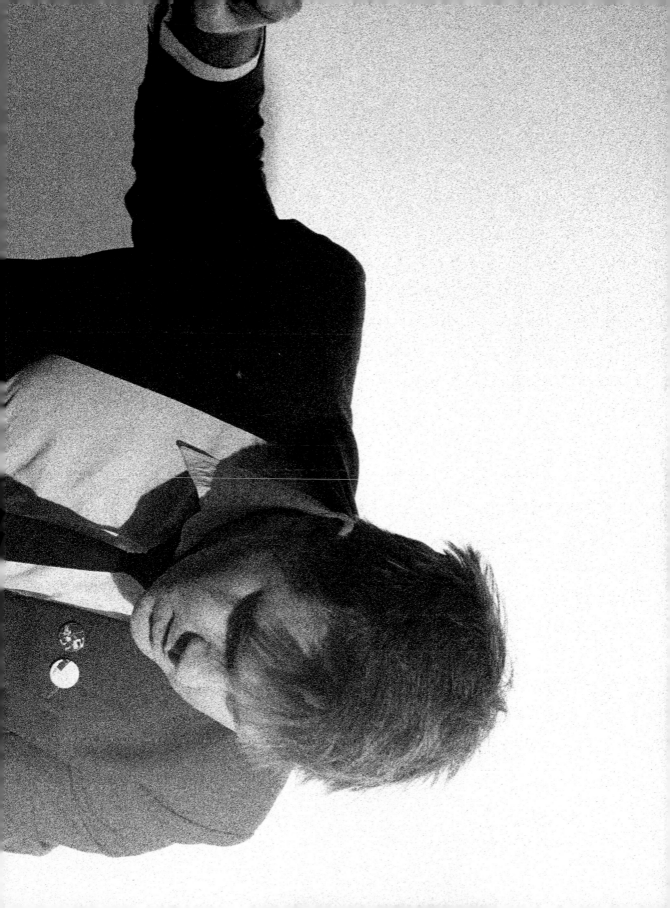

DRUNK GIRLS

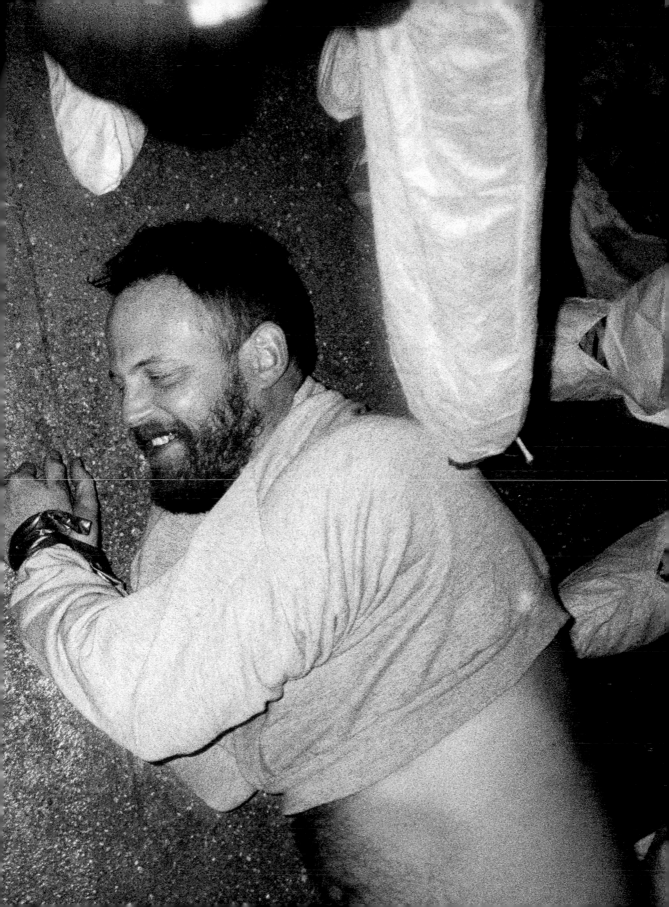

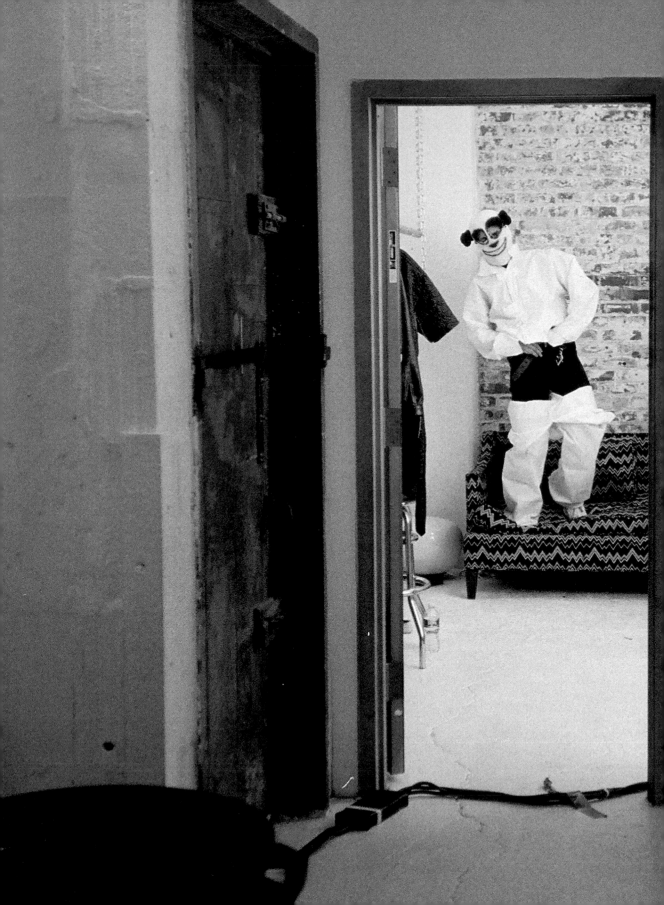

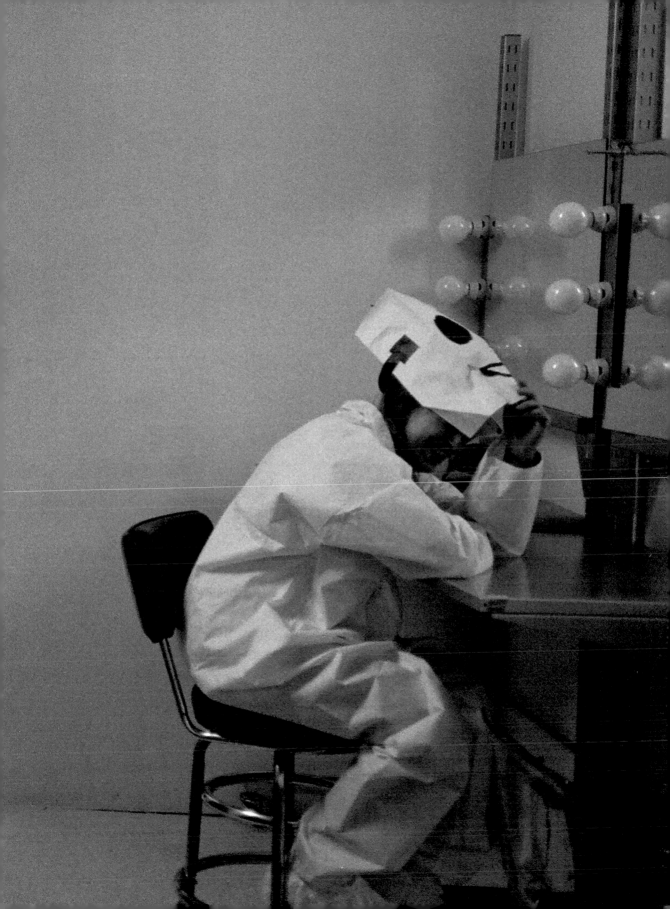

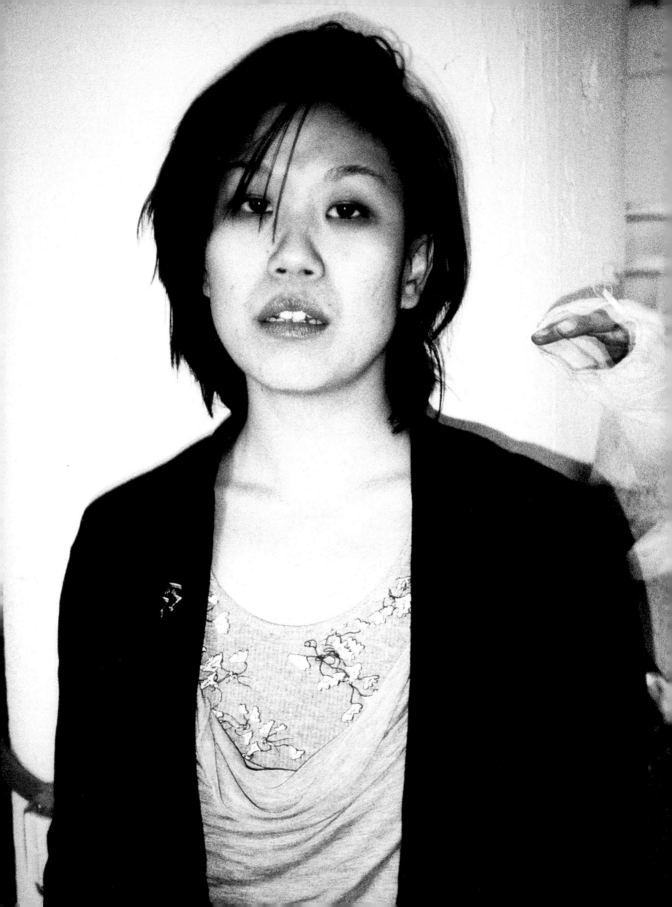

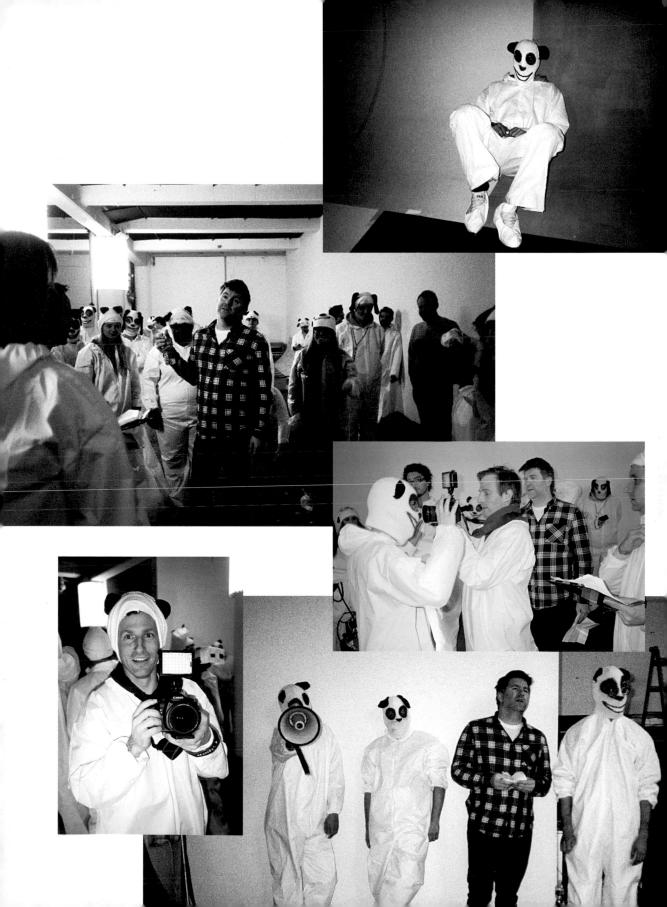

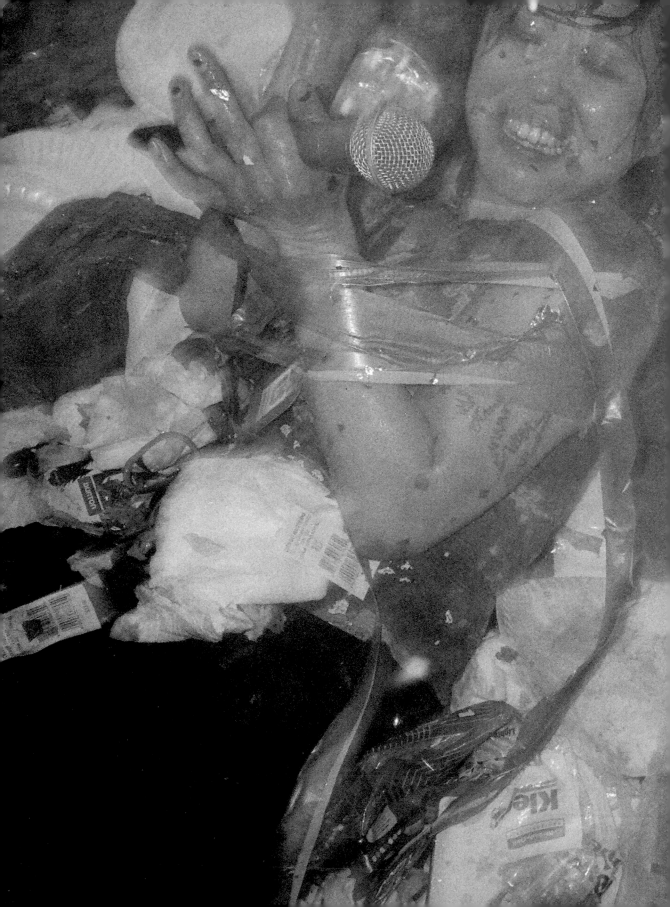

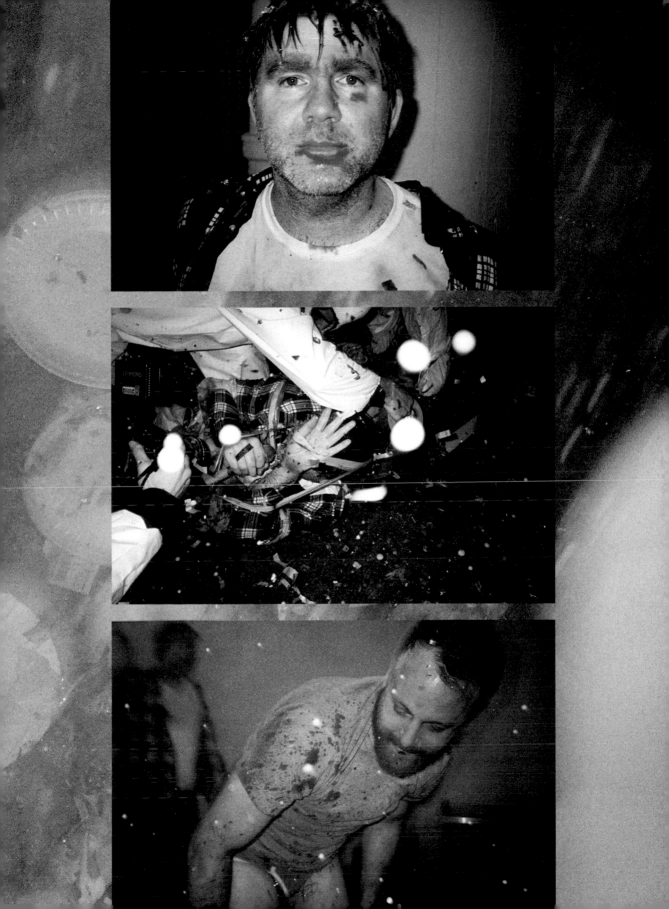

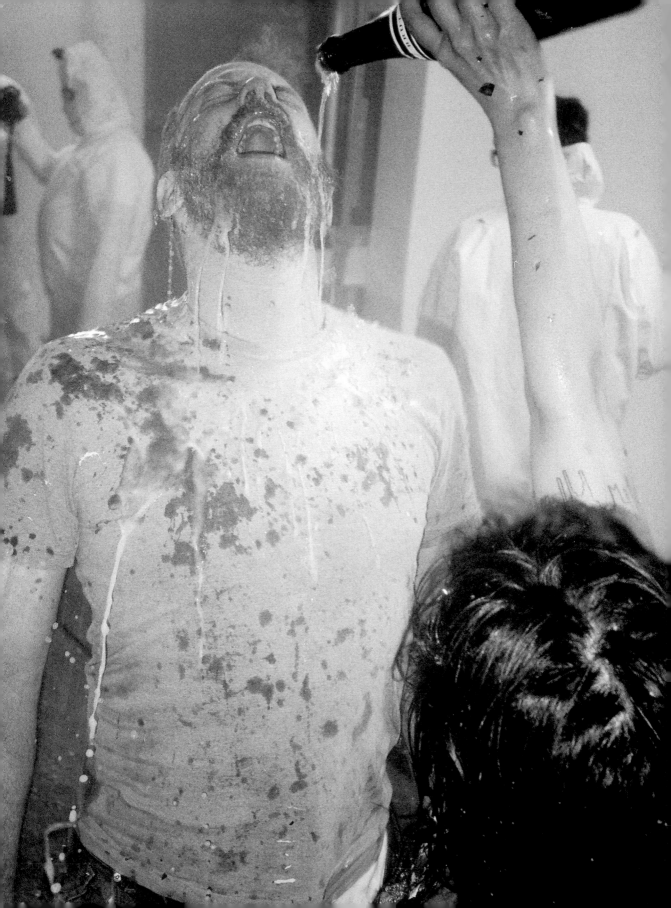

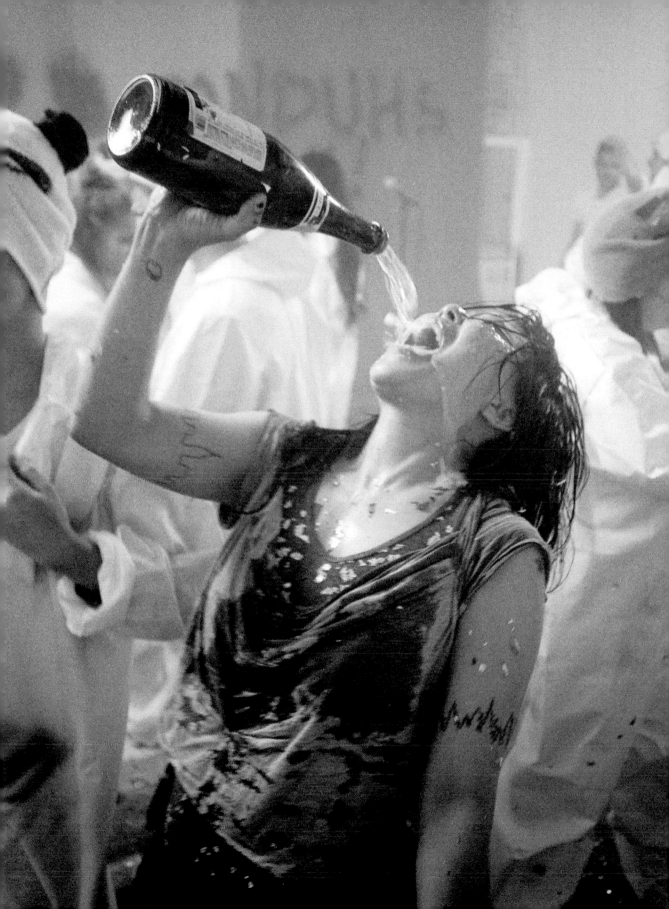

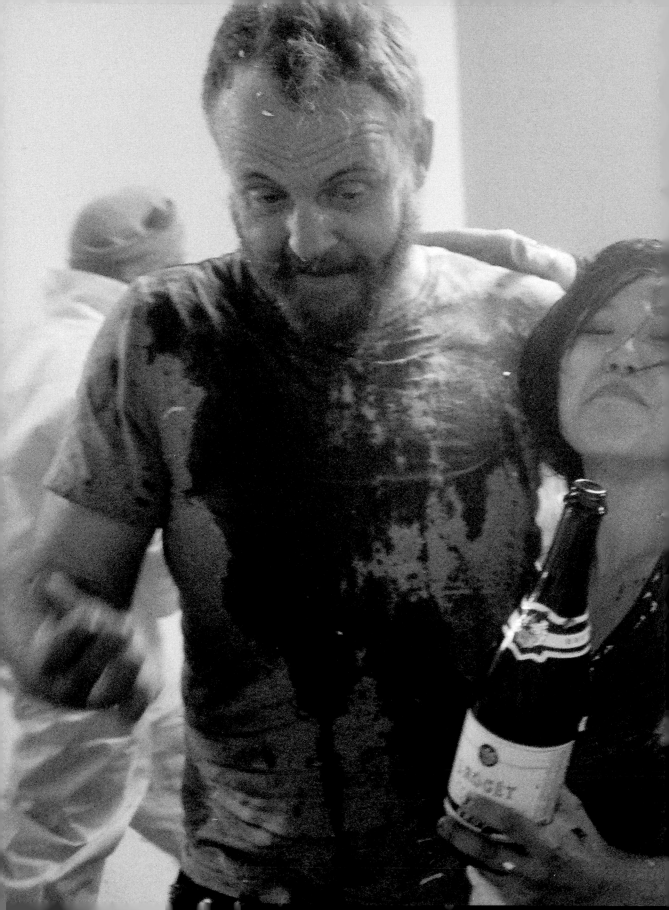

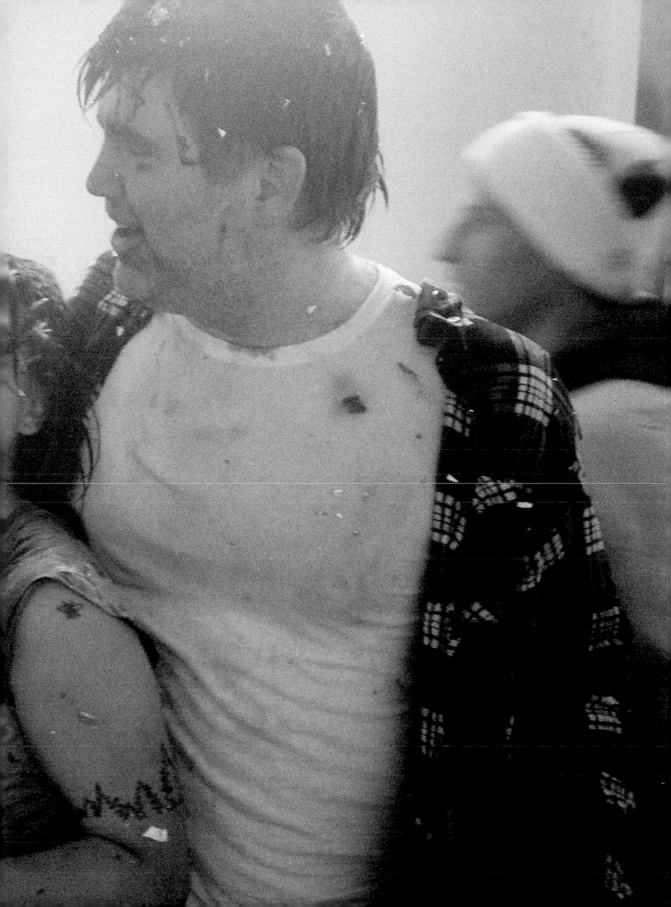

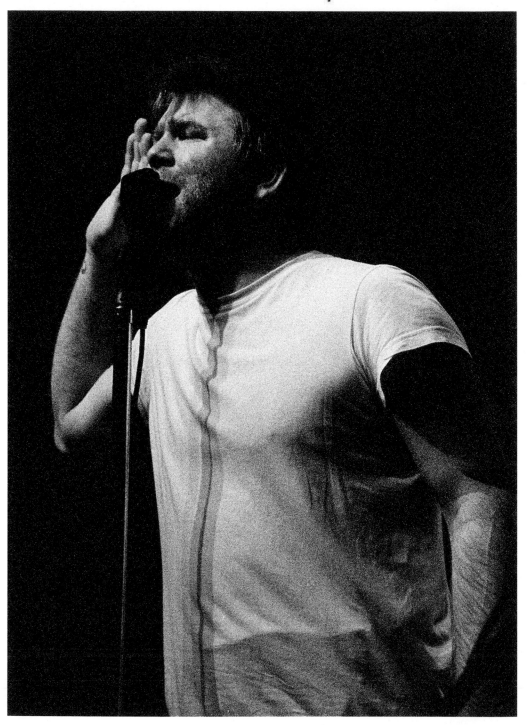

WILLIAMSBURG

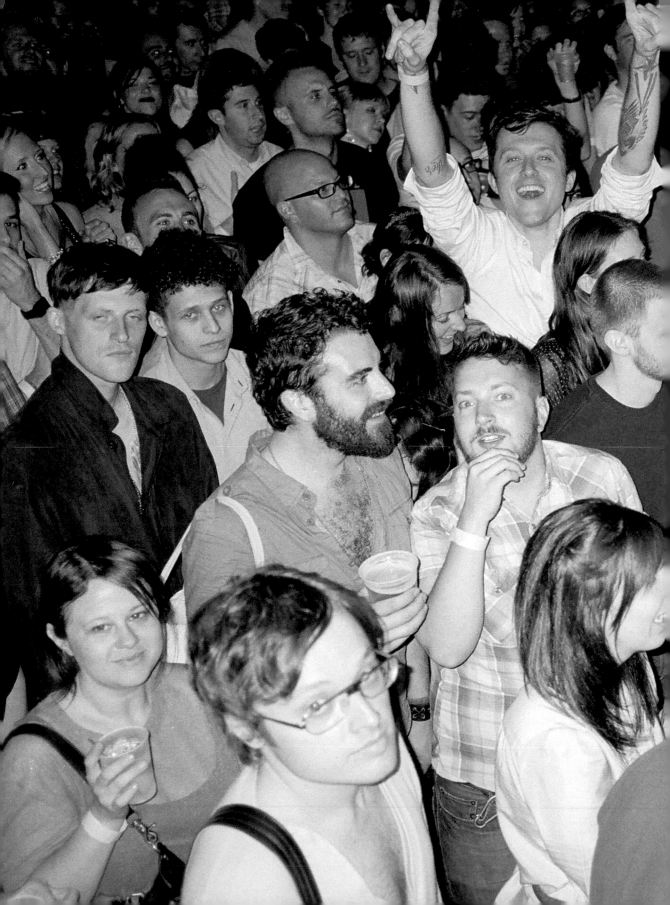

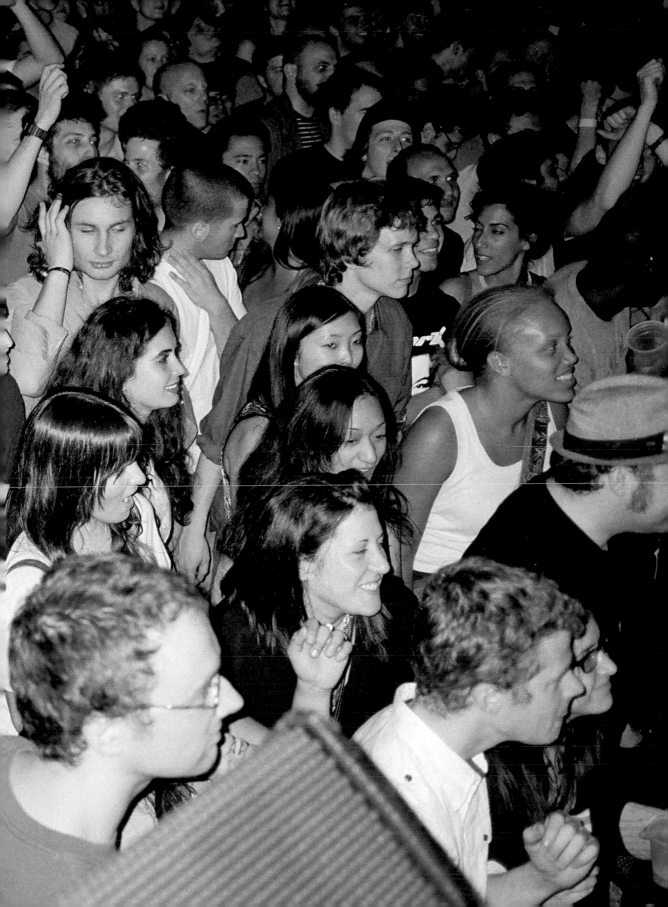

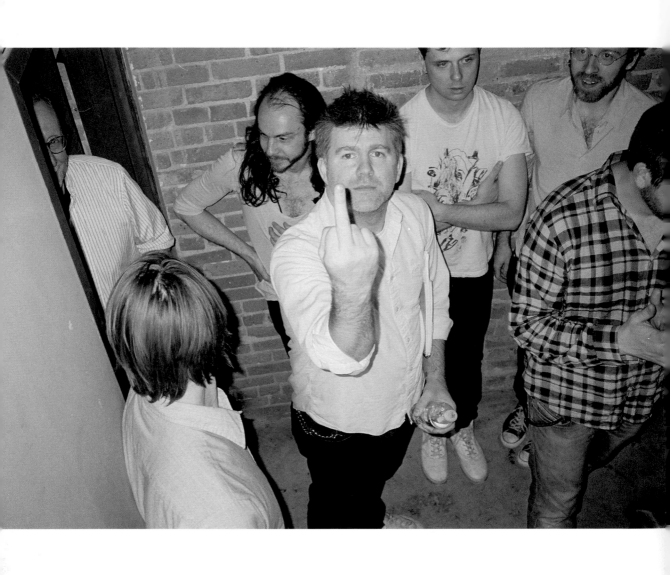

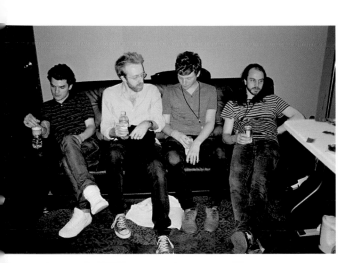
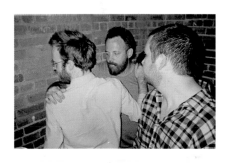
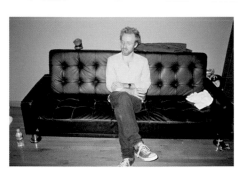
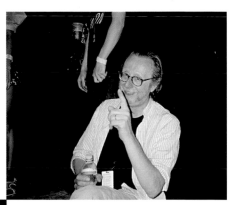

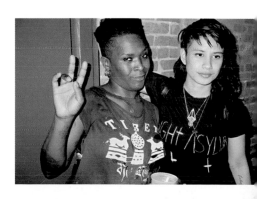

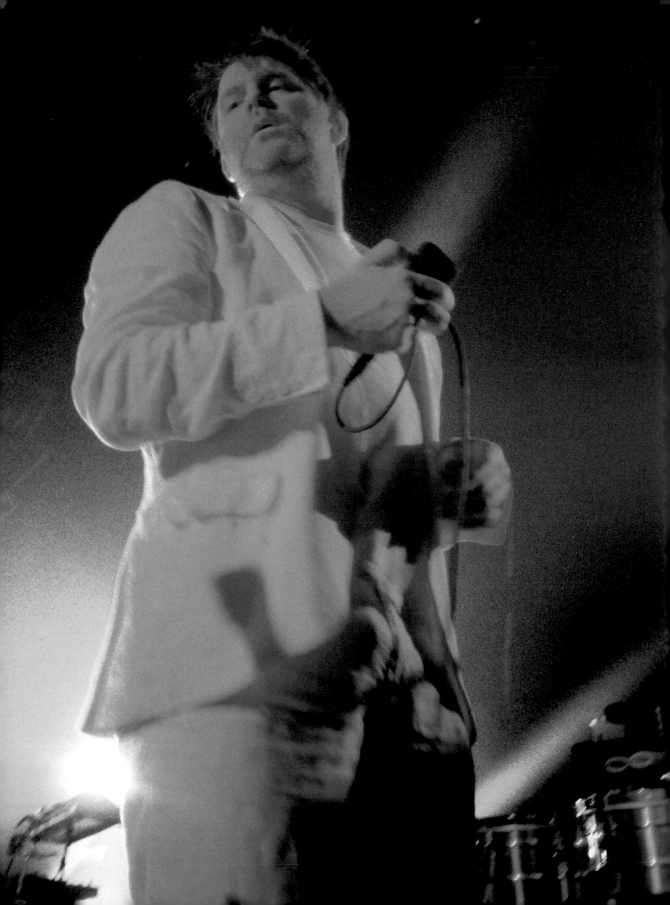

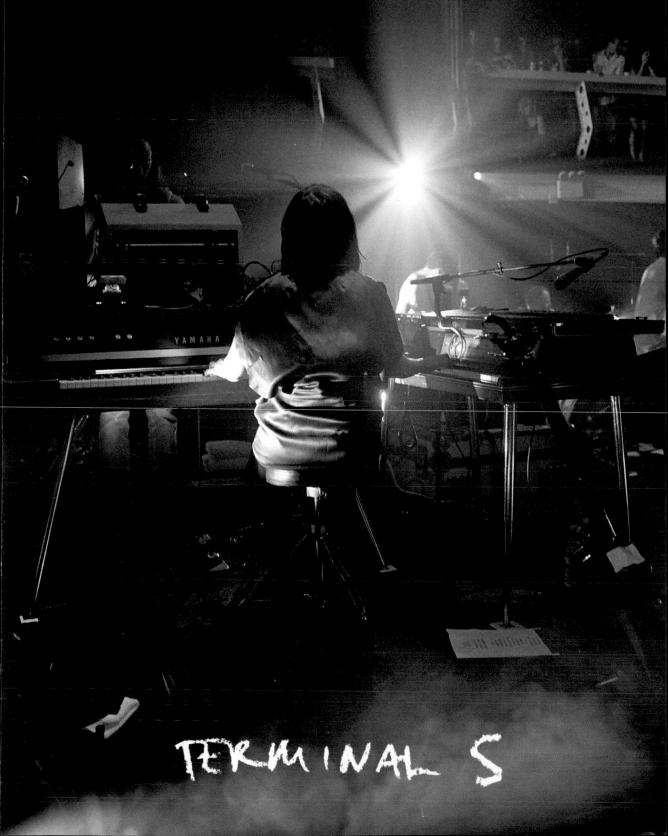

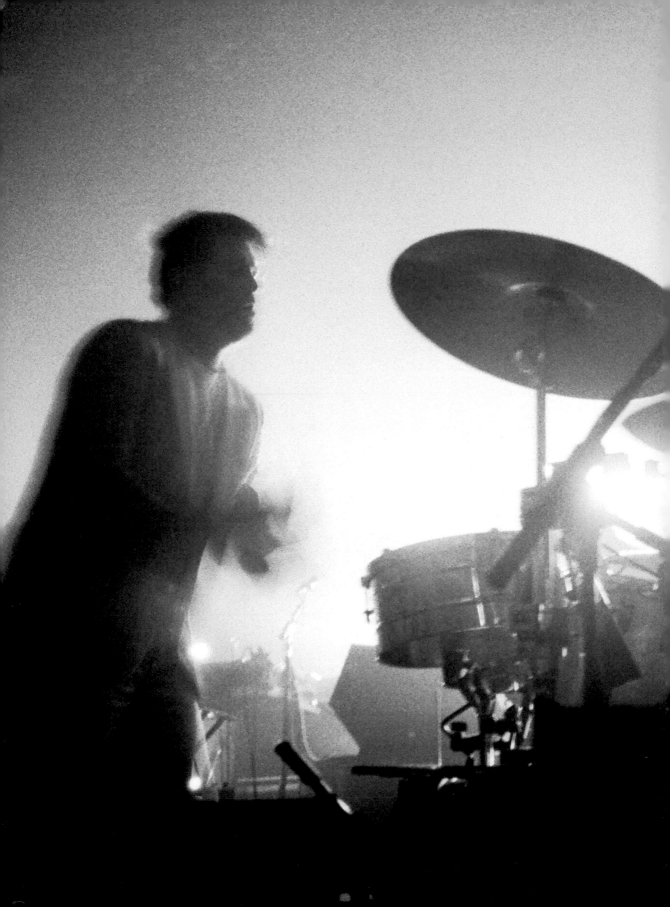

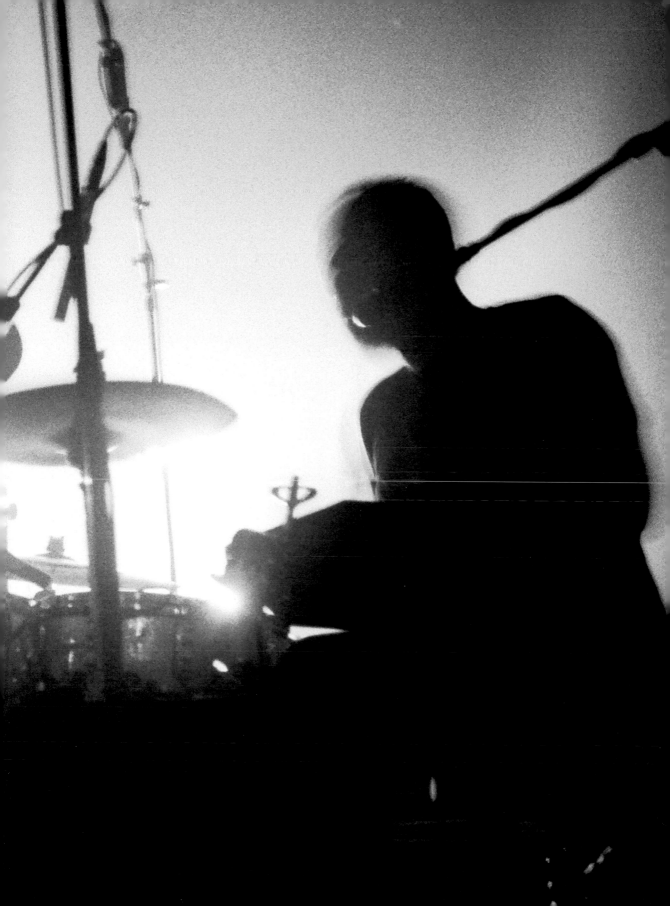

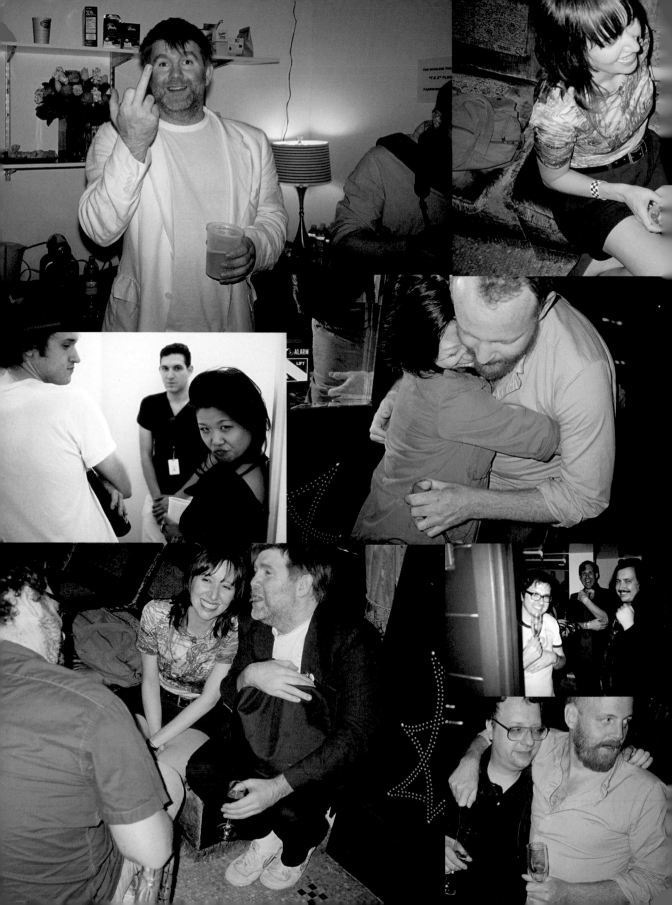

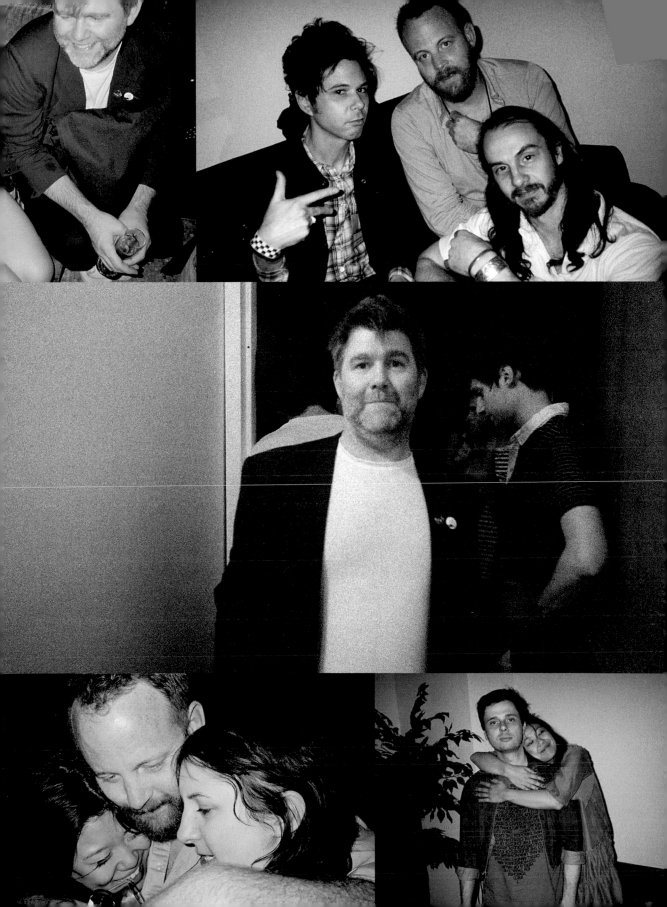

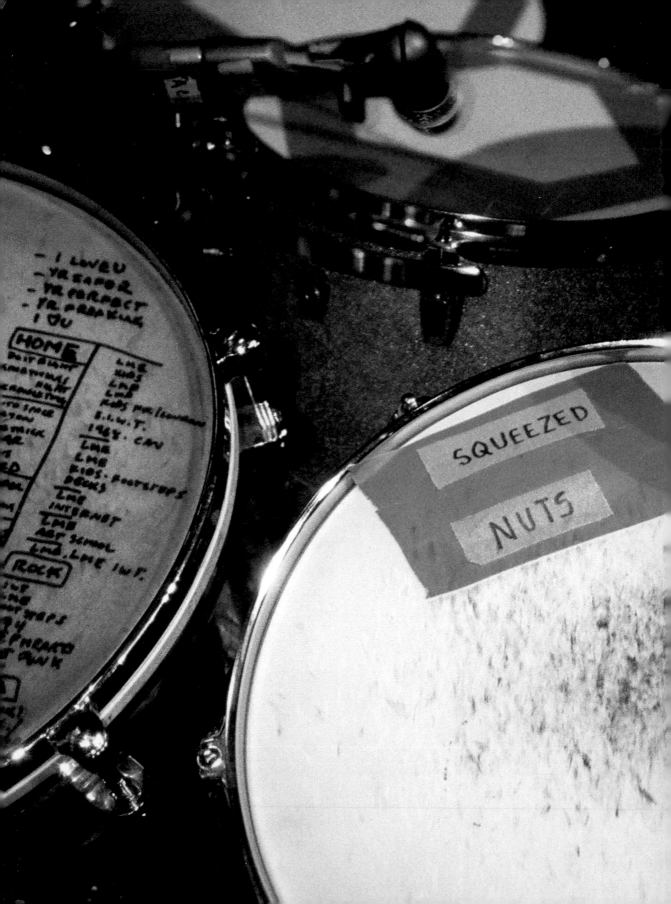

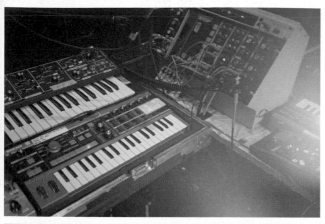
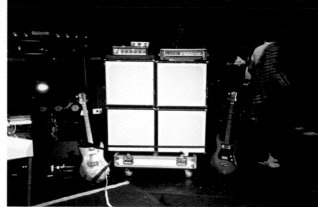

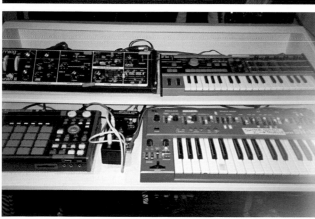
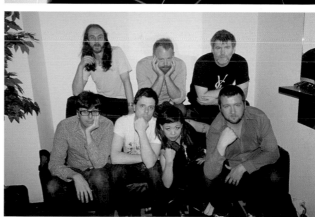
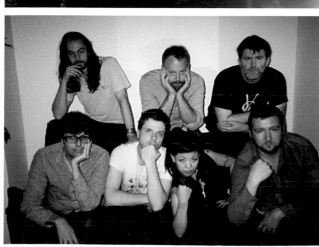

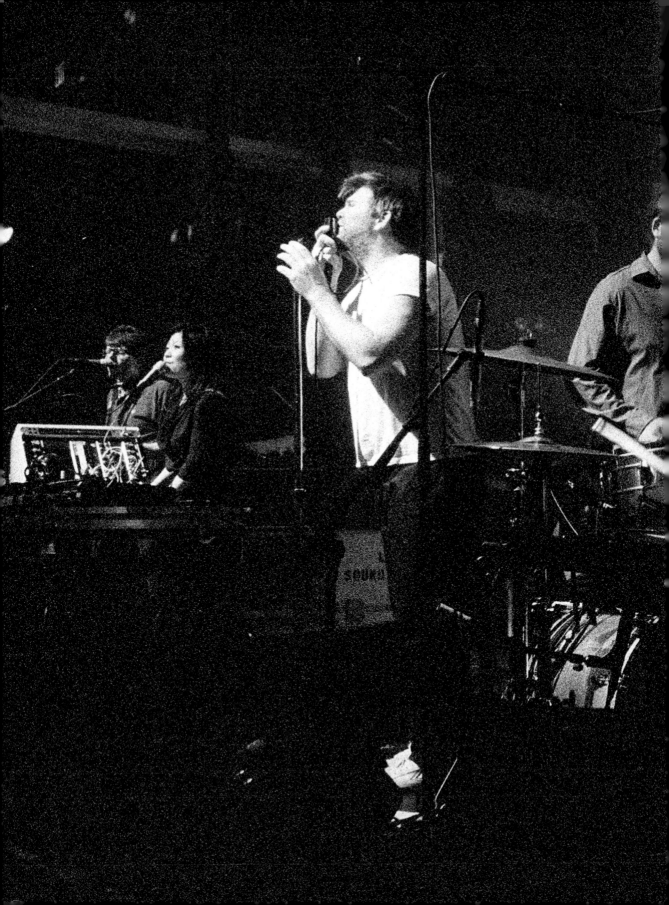

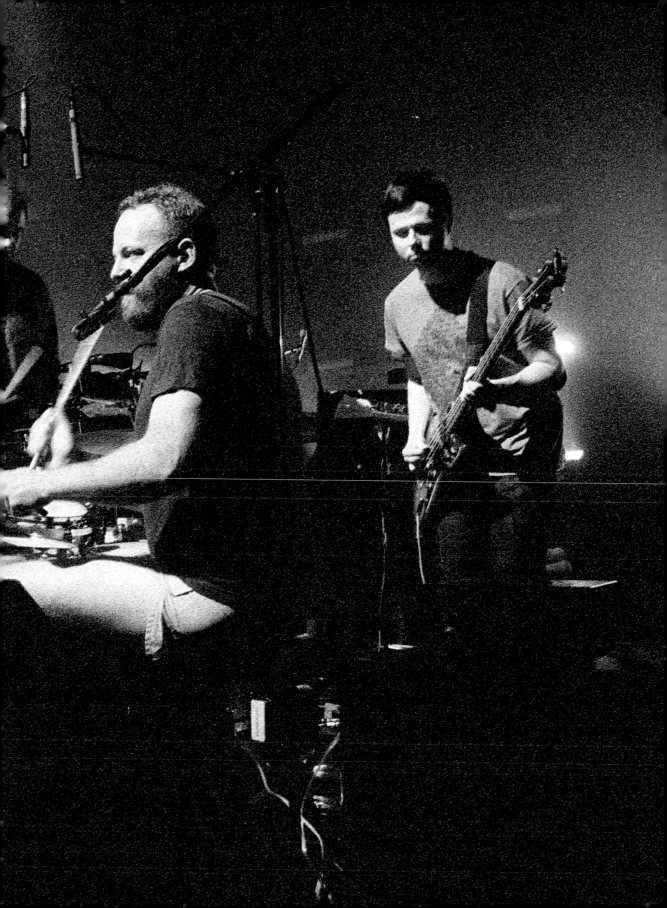

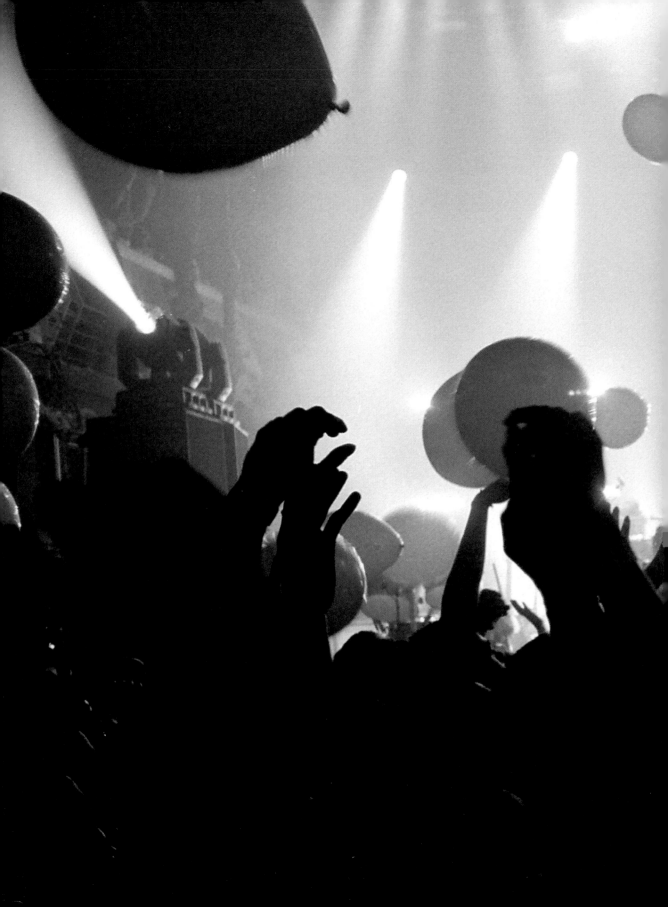

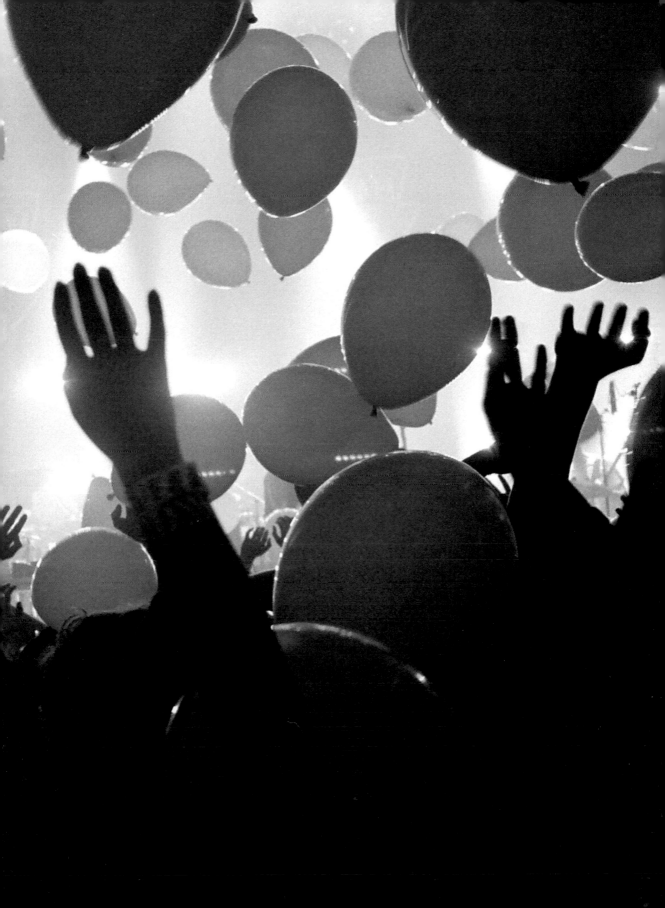

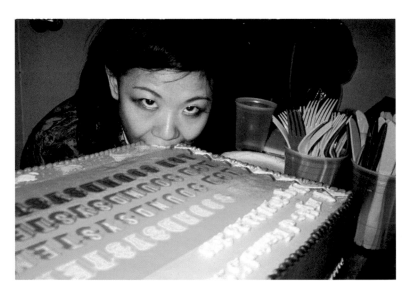

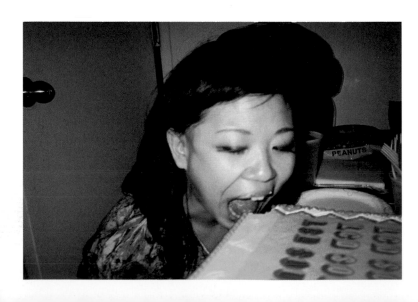

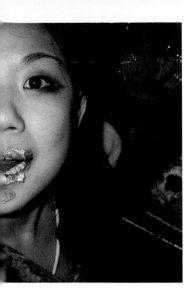

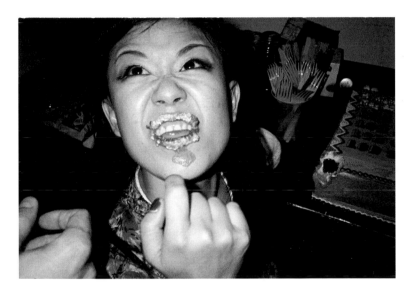

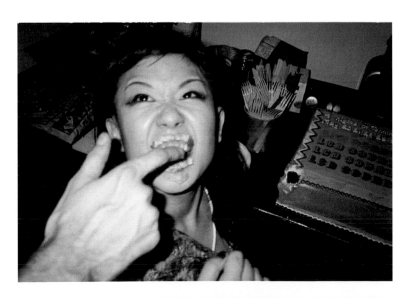

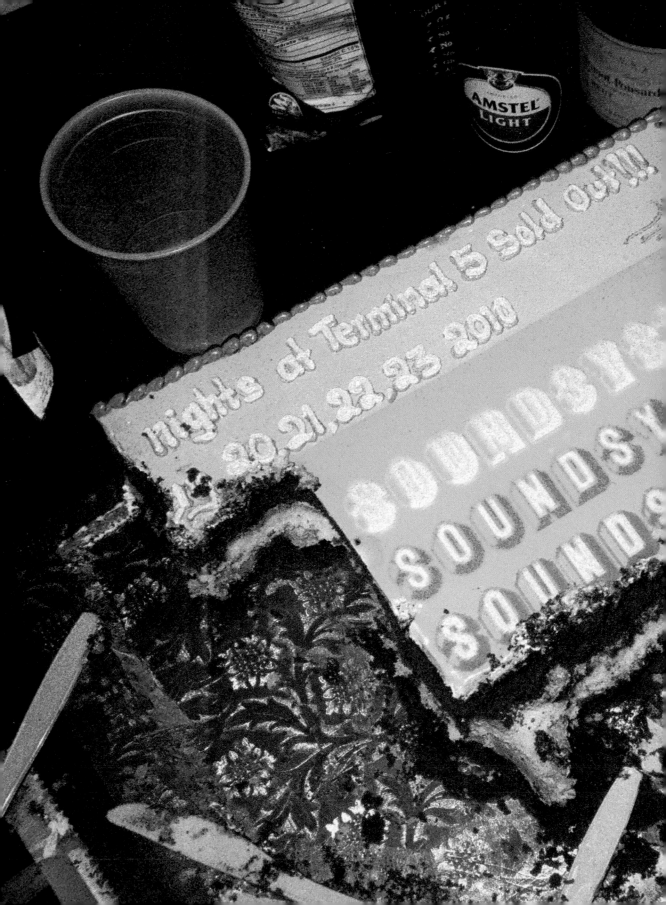

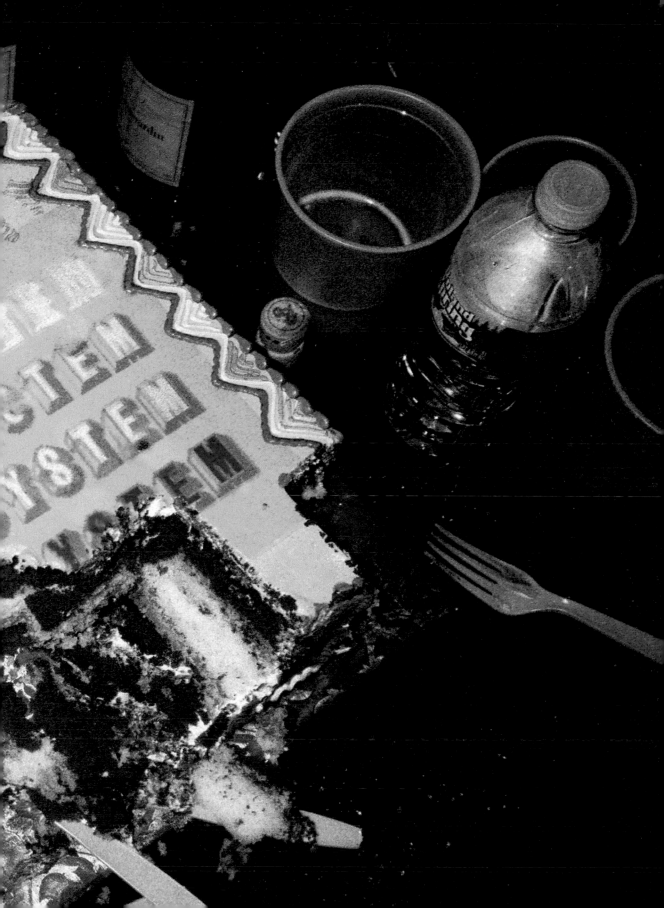

COACHELLA

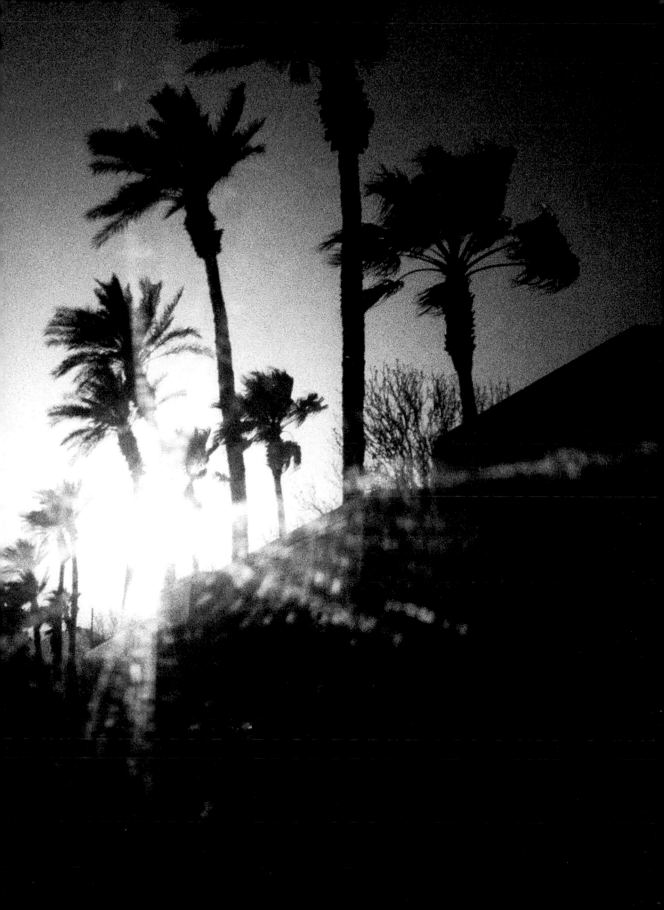

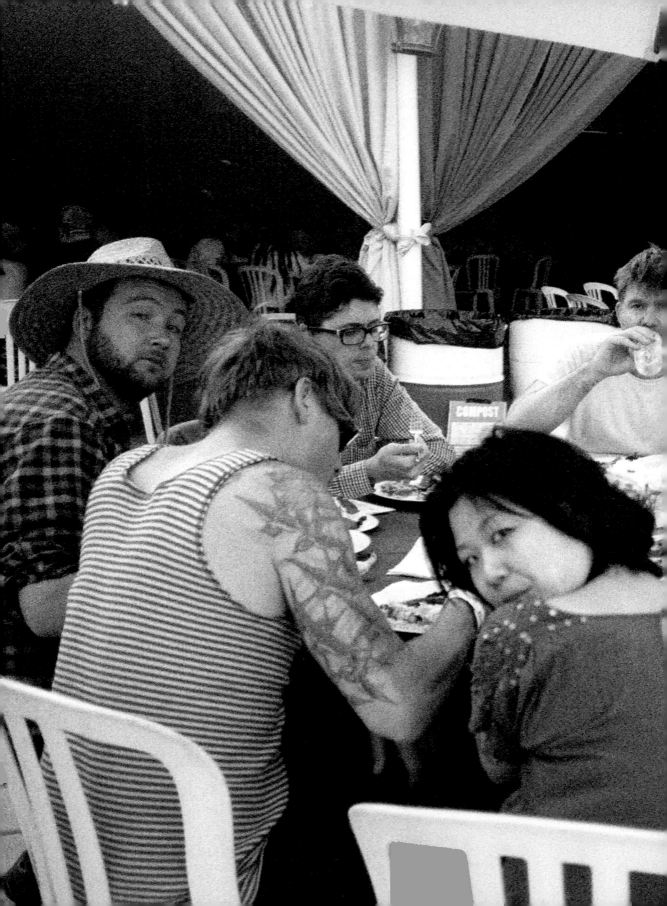

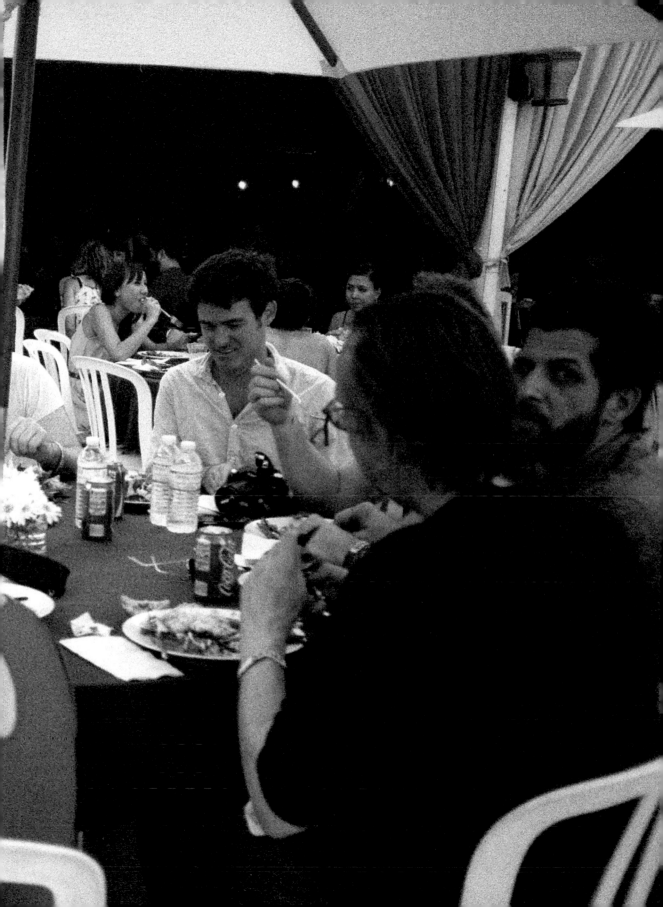

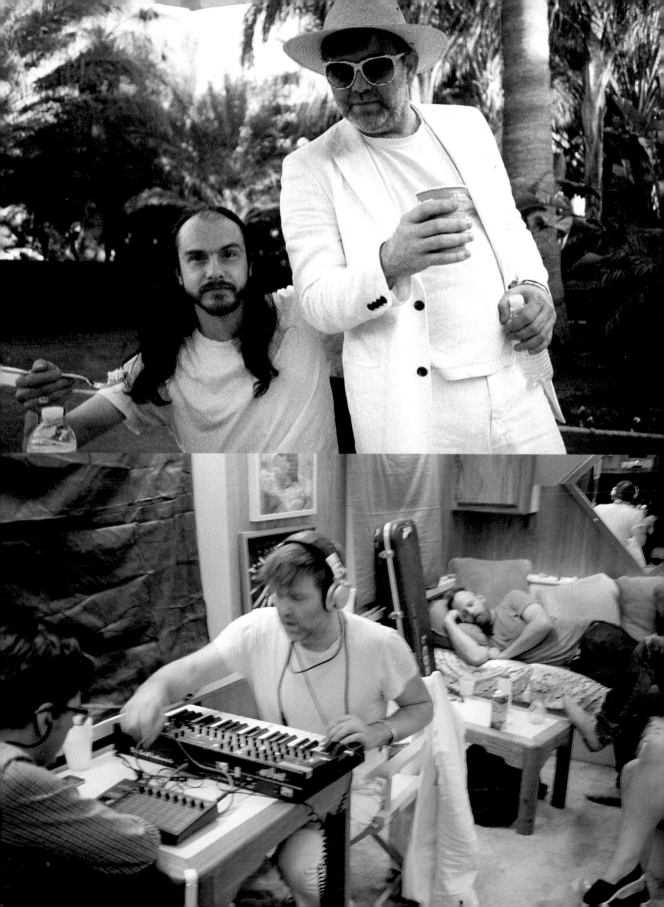

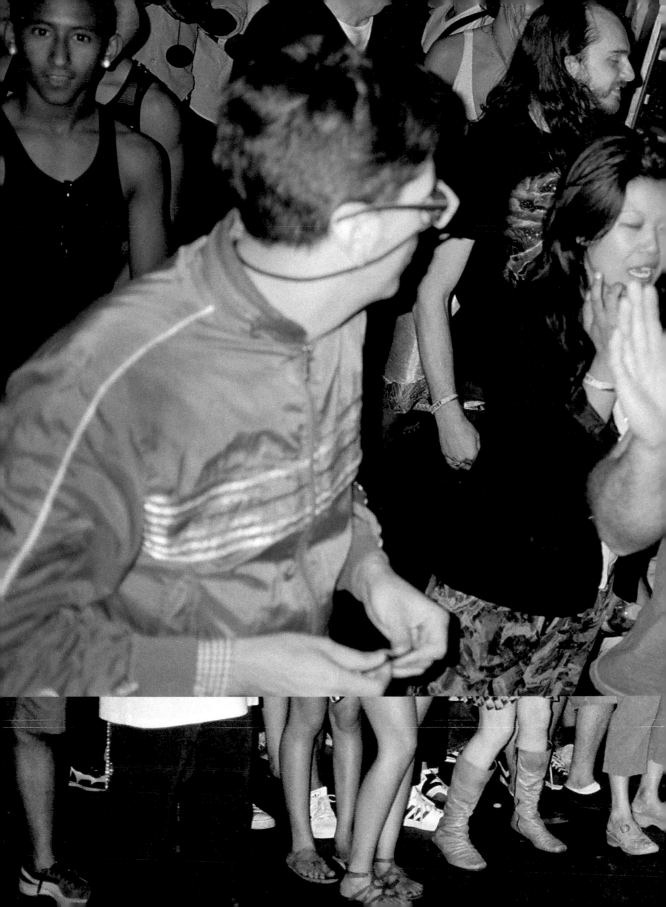

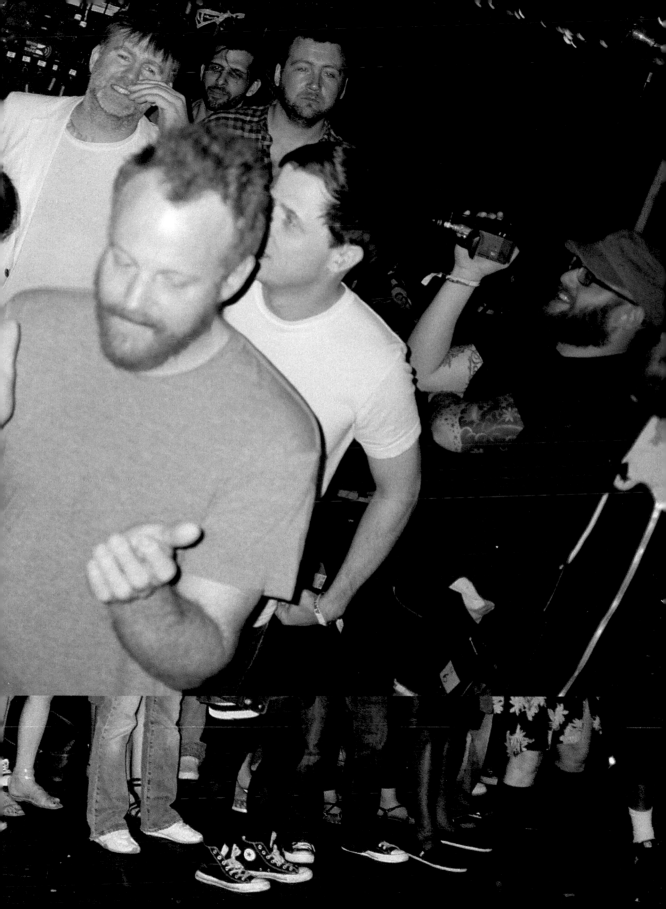

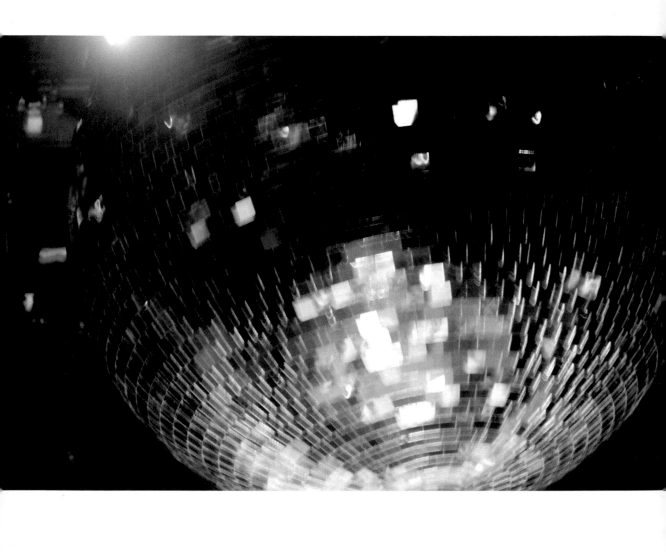

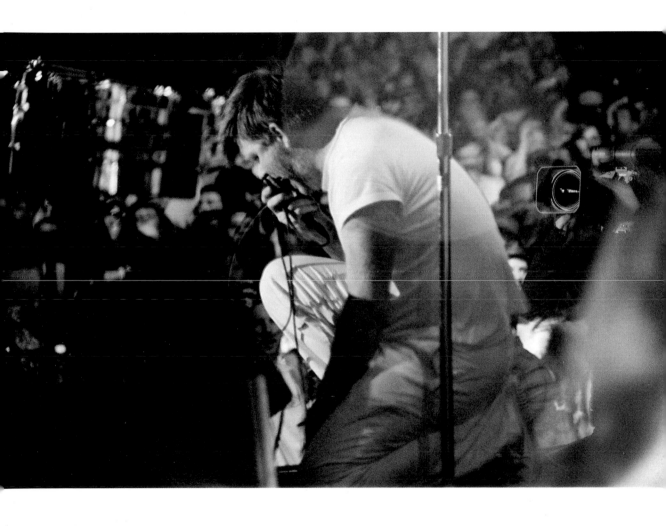

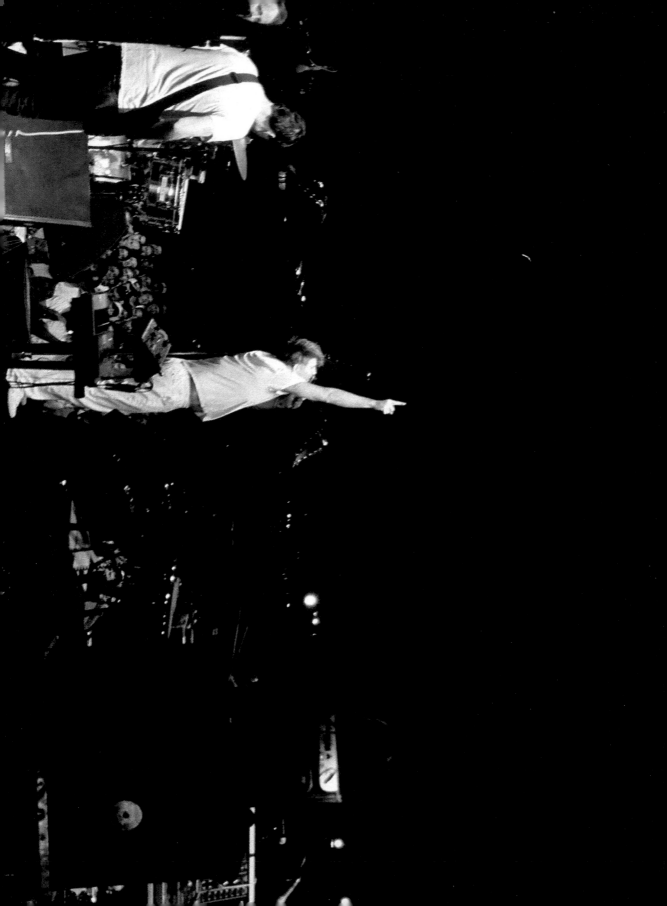

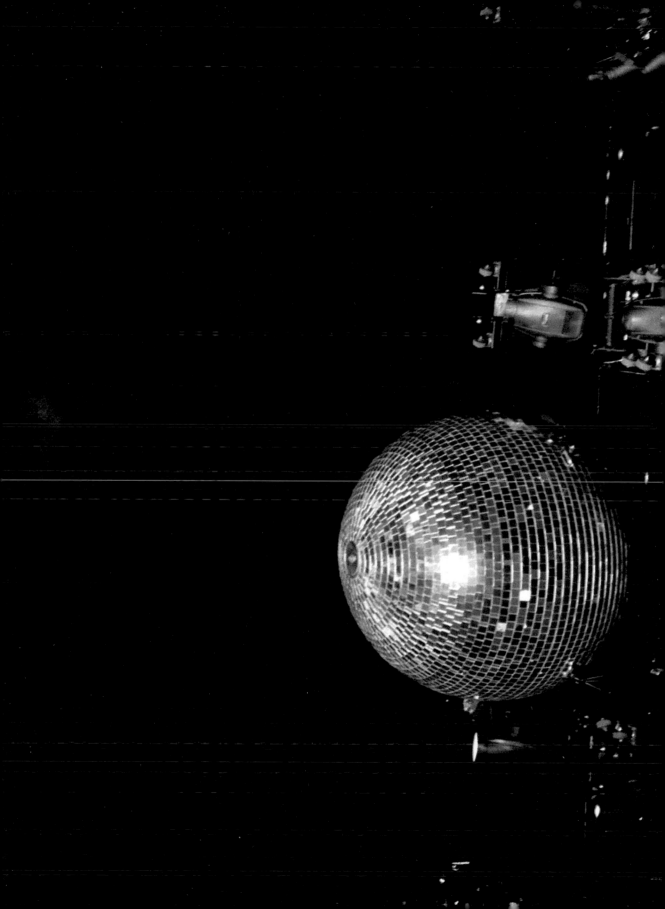

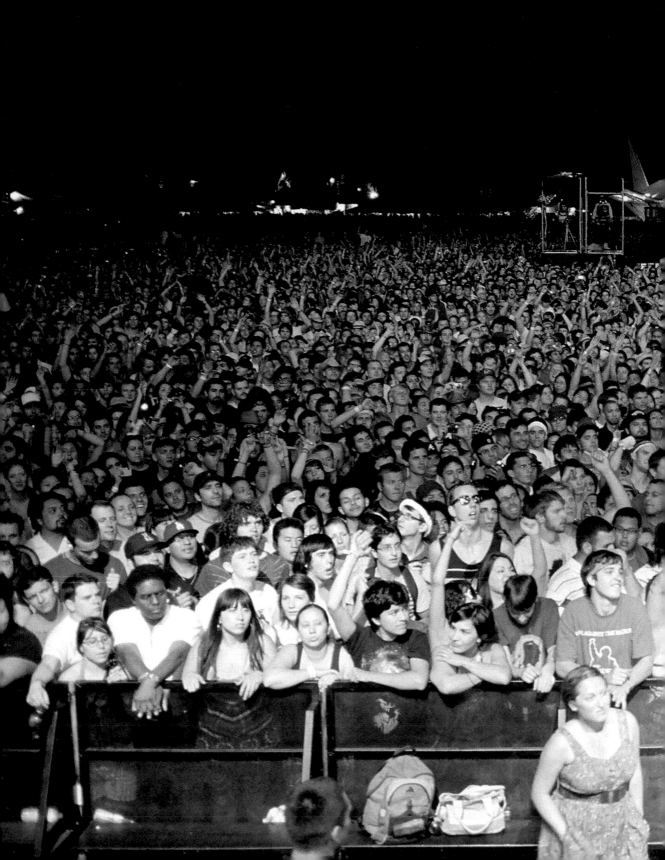

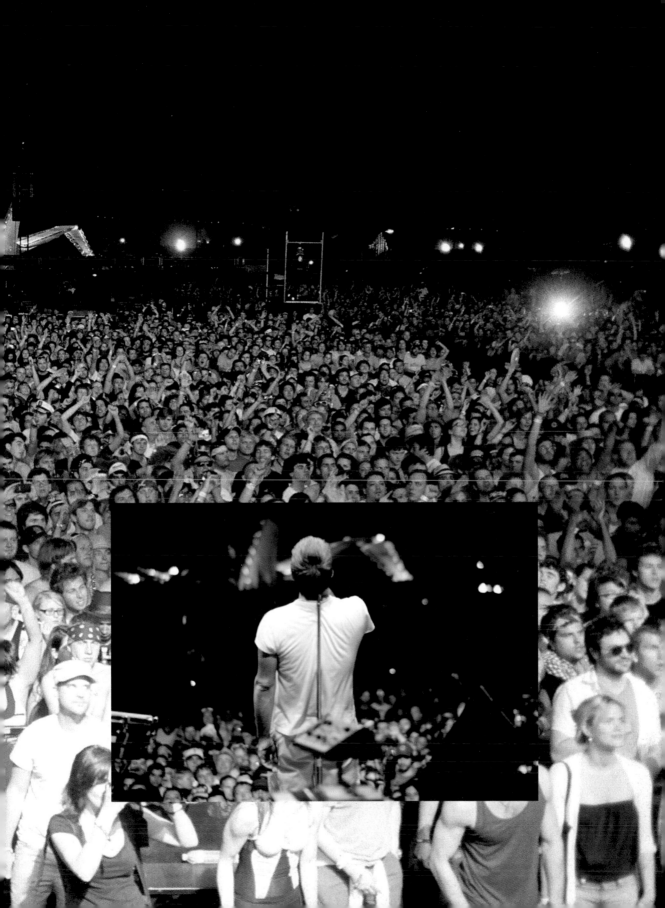

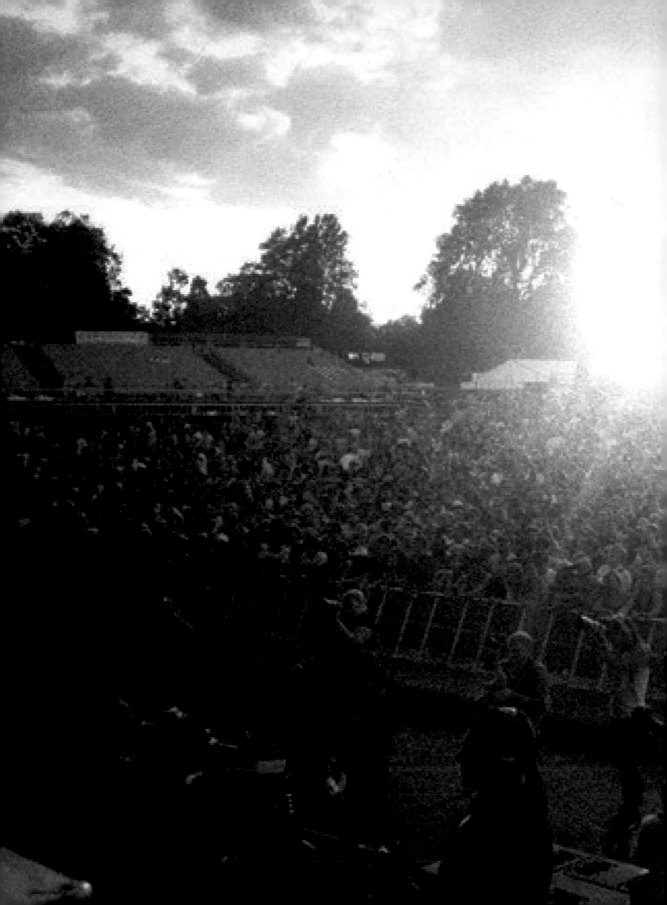

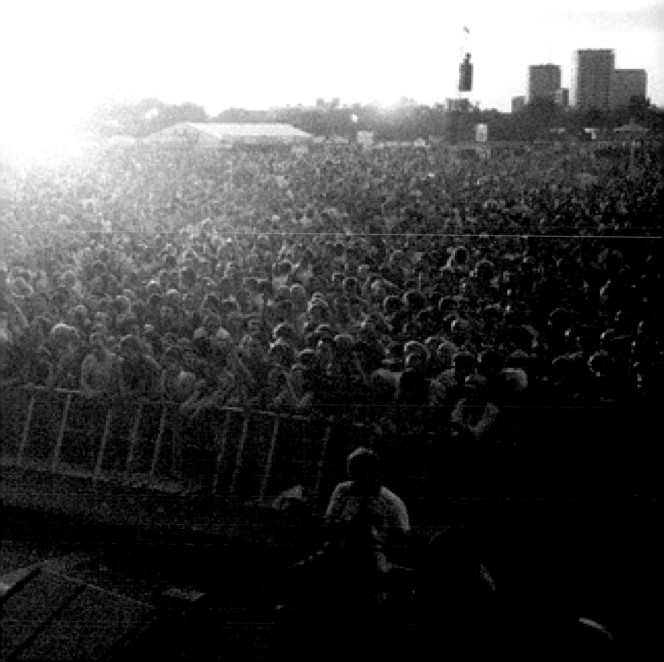

HYDE PARK, LONDON

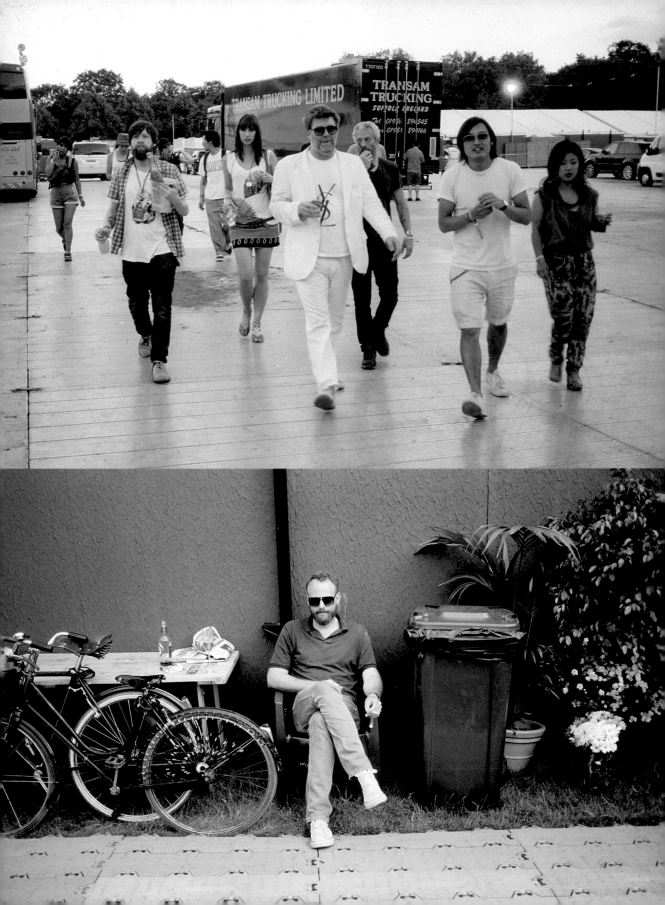

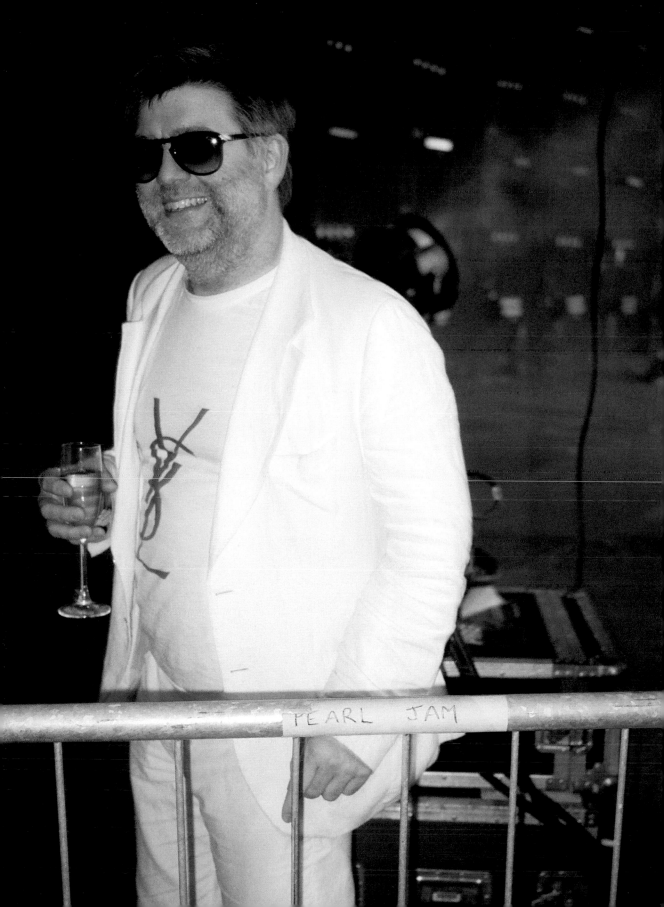

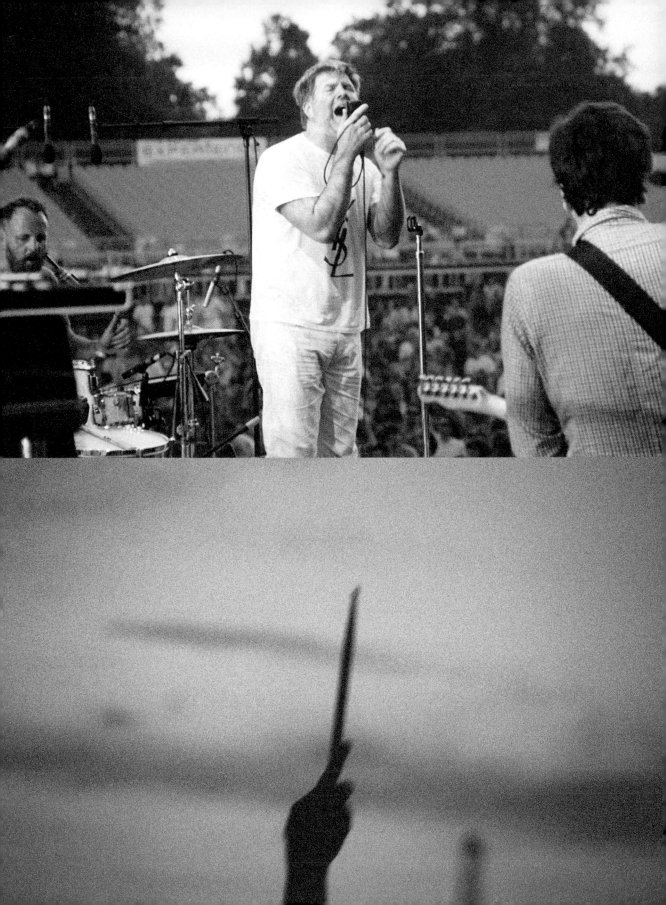

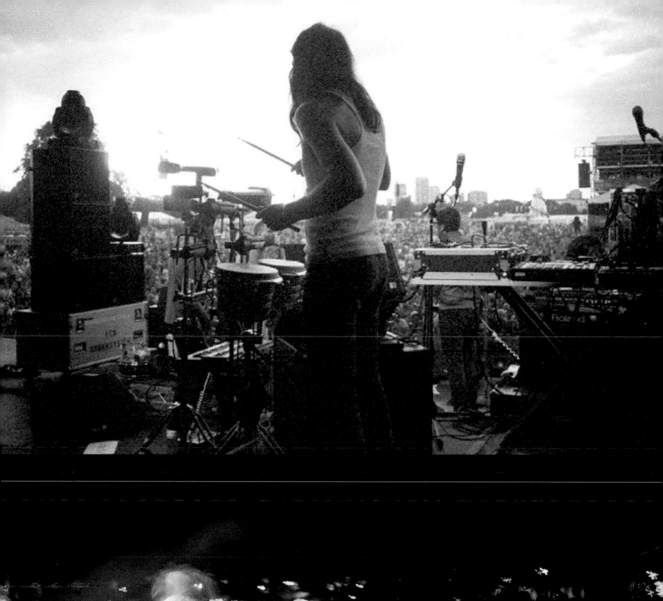
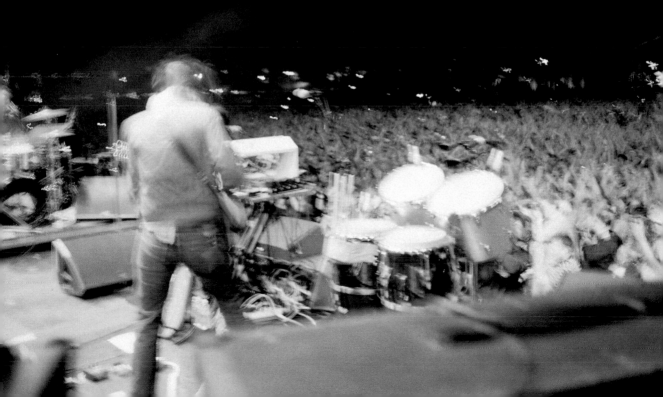

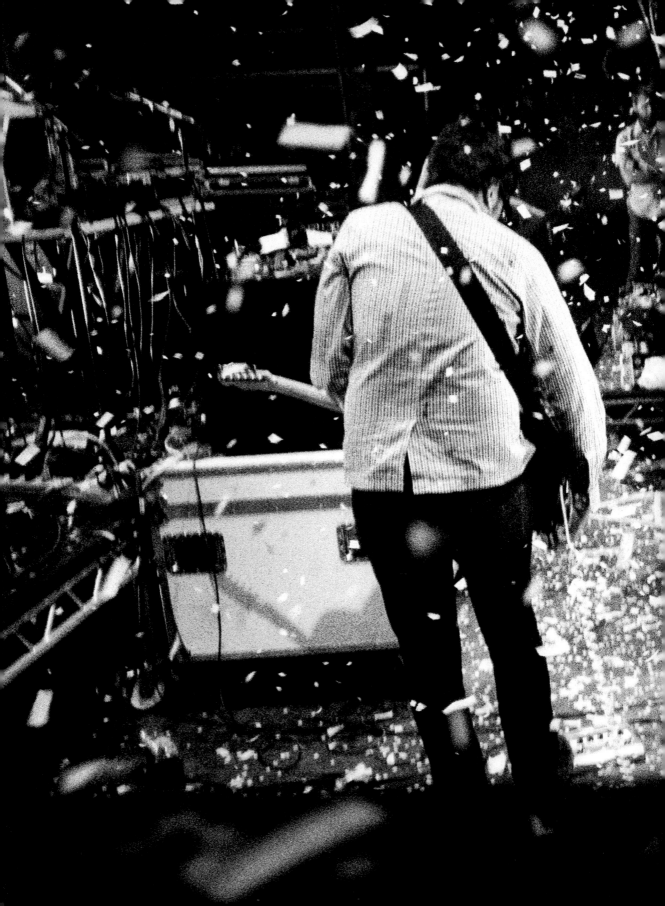

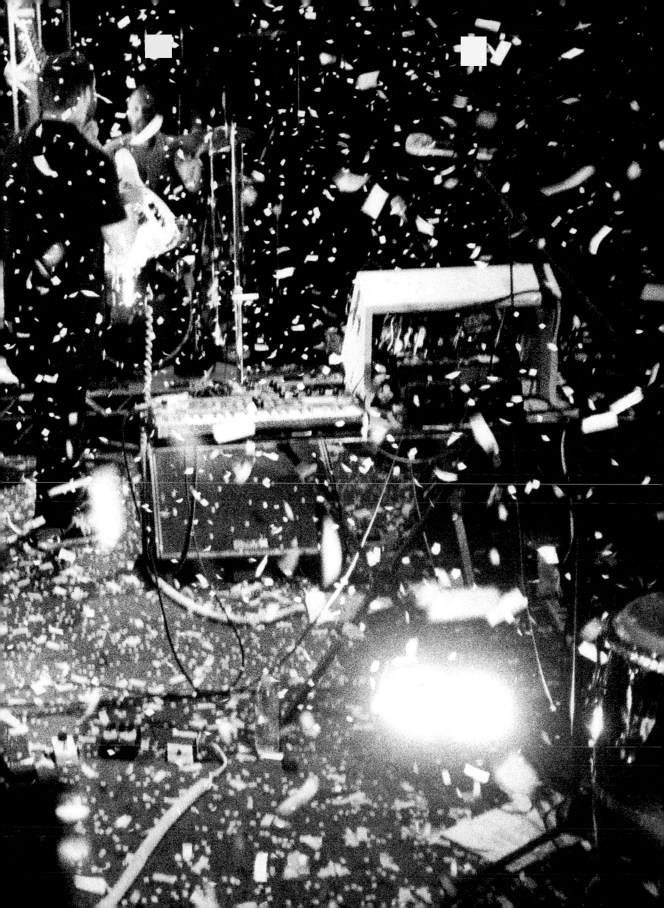

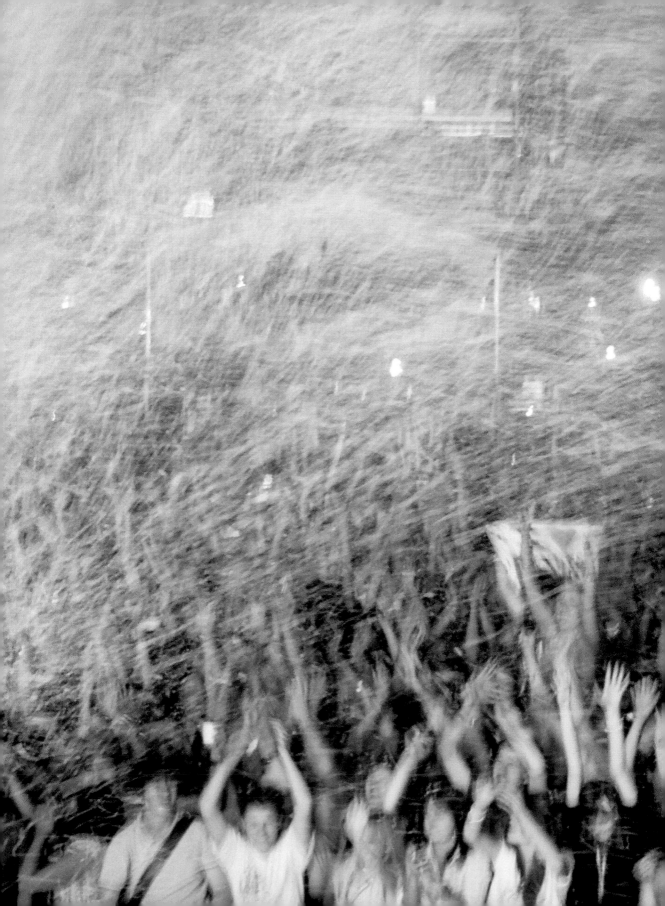

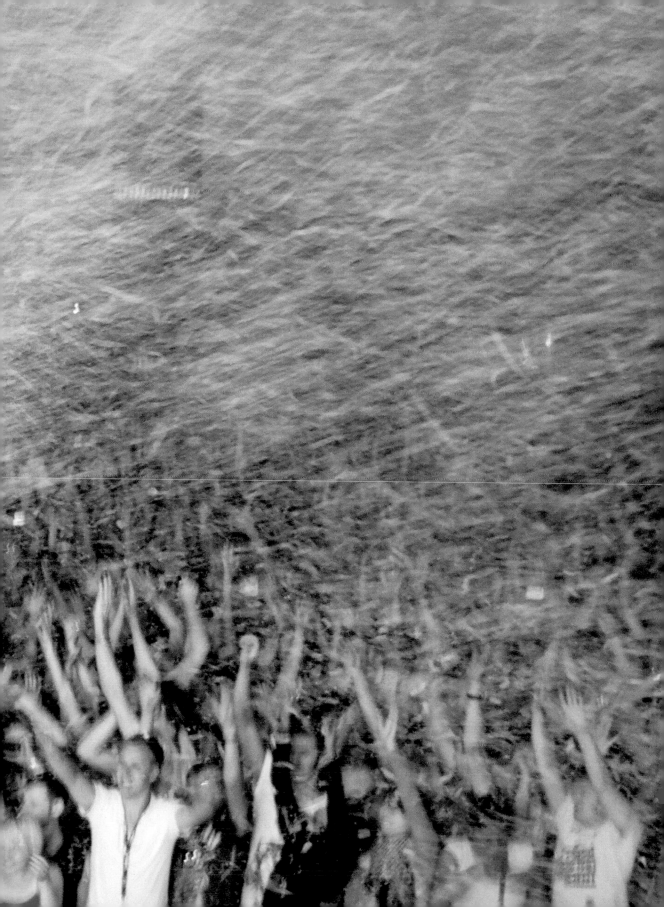

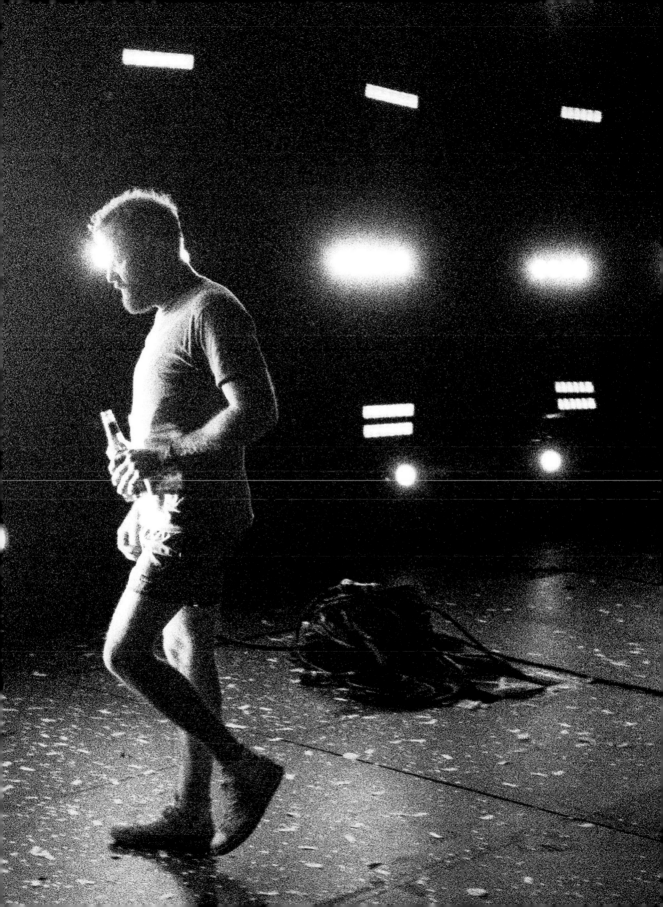

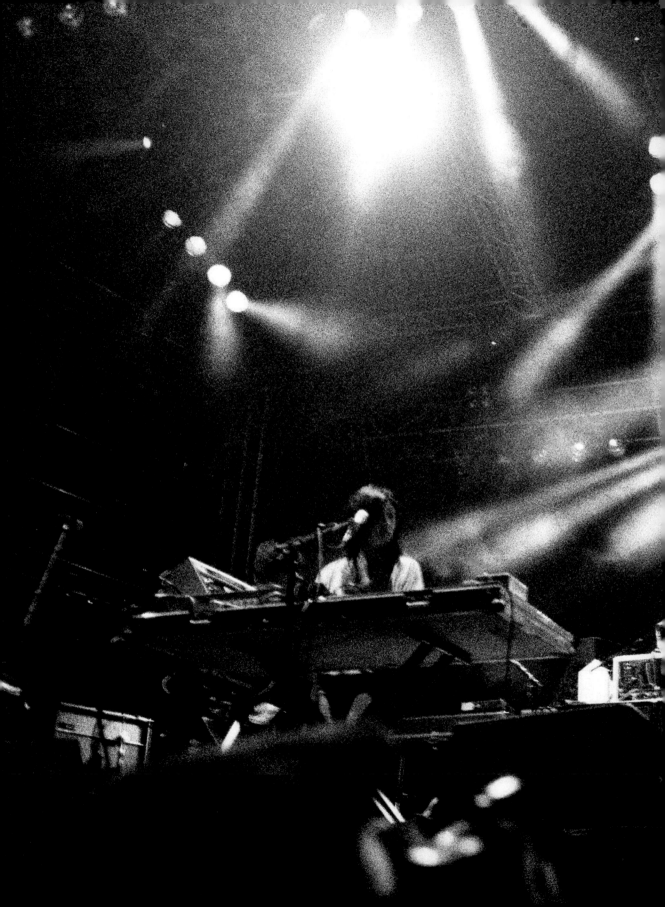

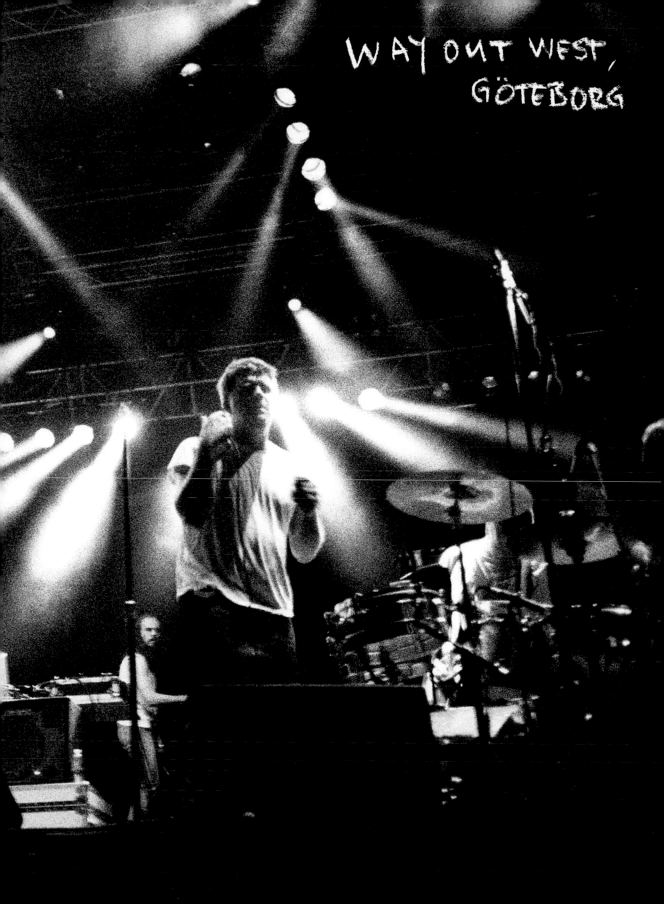

WAY OUT WEST,
GÖTEBORG

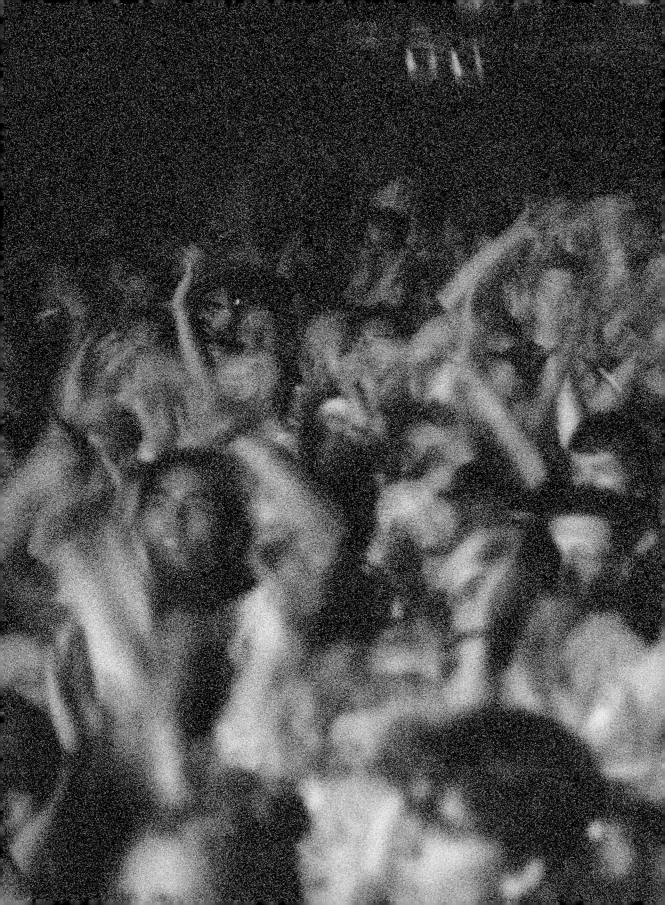

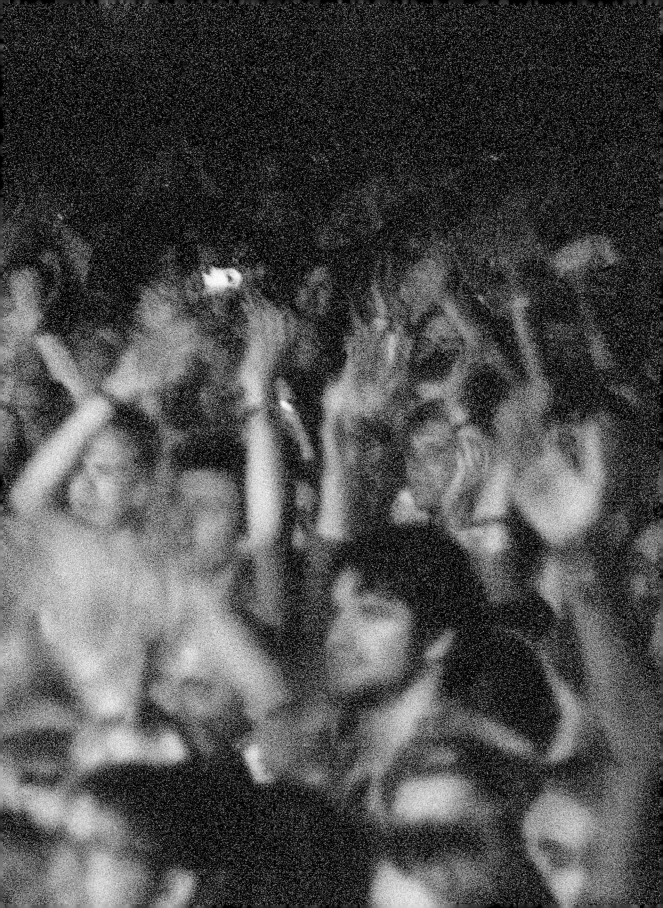

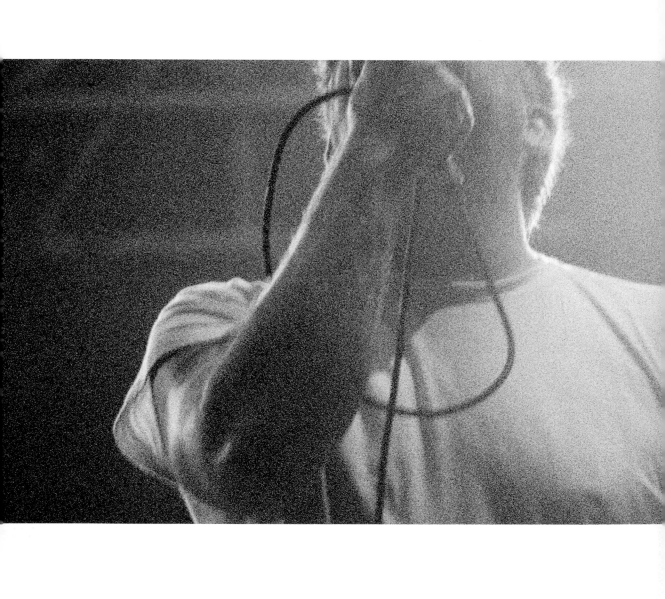

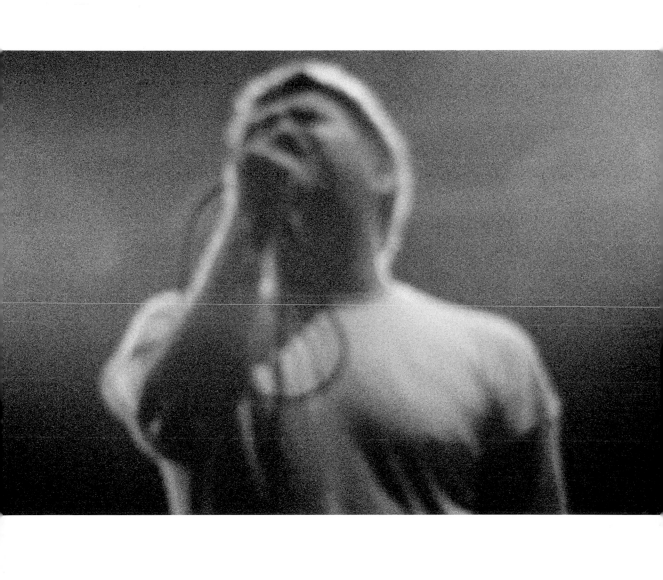

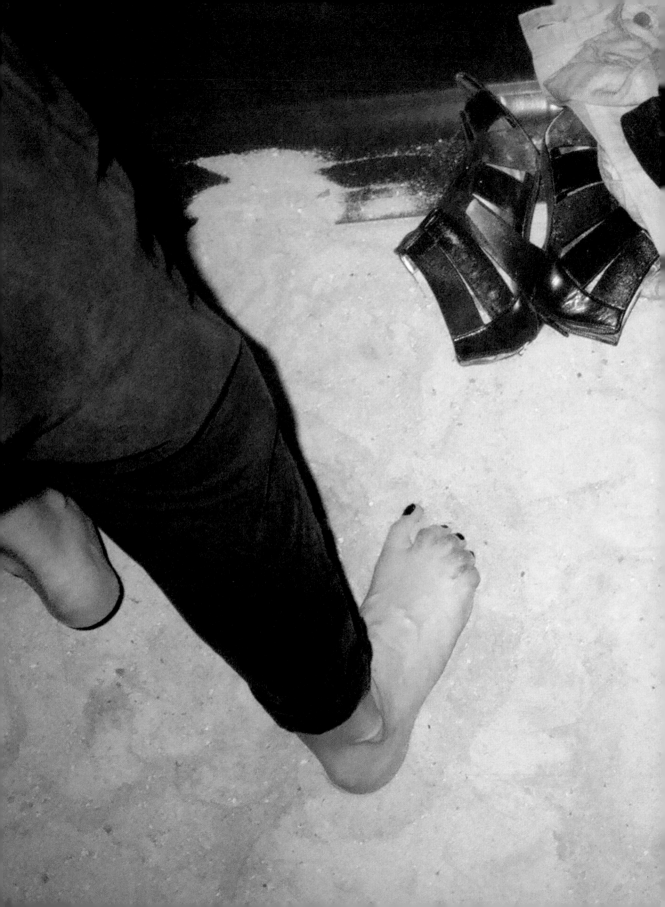

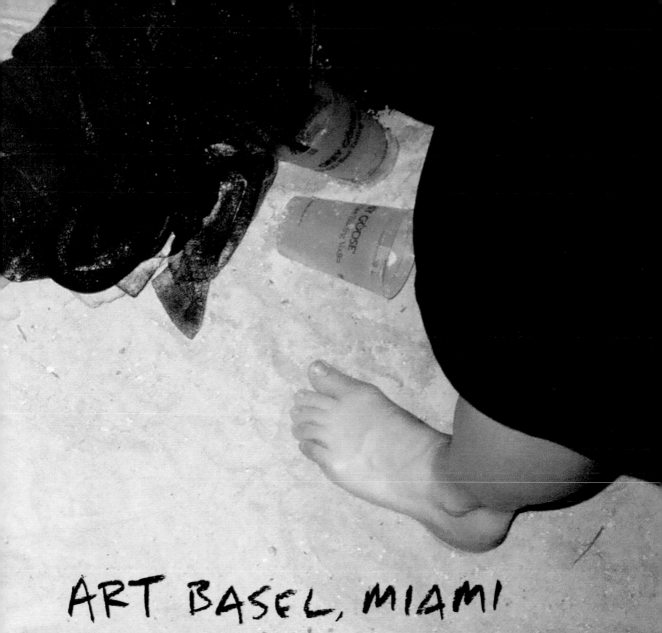

ART BASEL, MIAMI

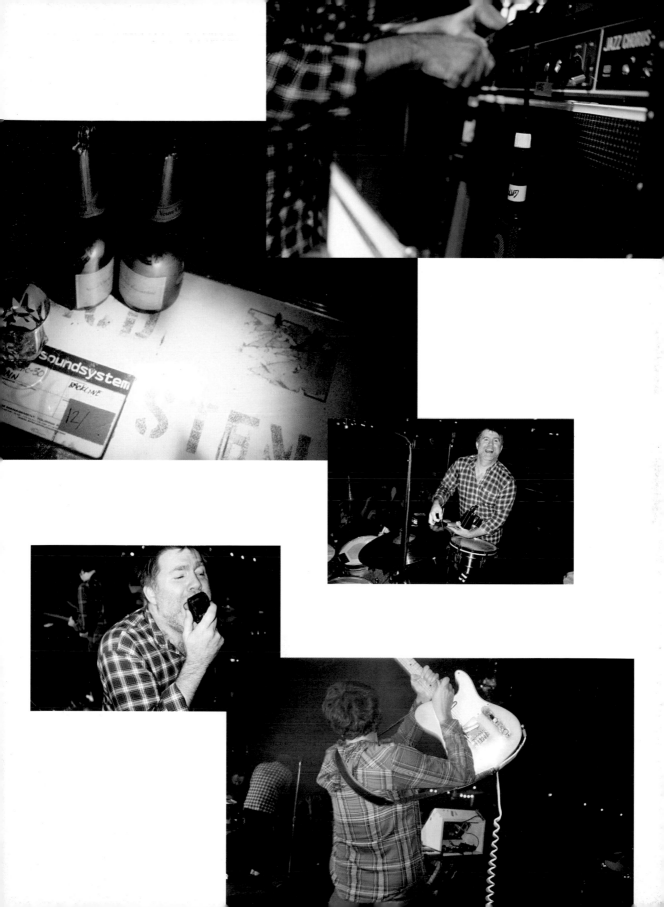

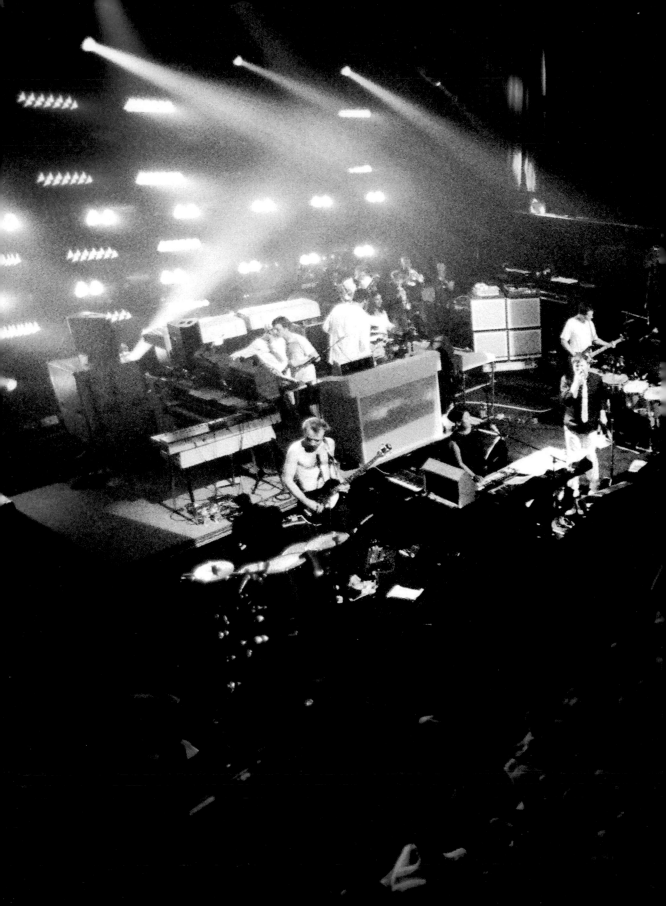

TERMINALLY 5

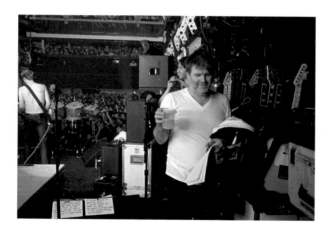

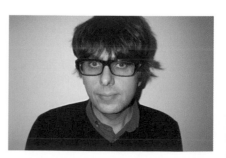

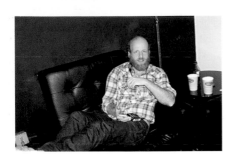

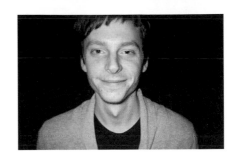

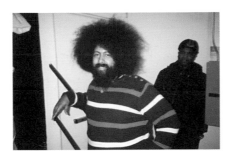

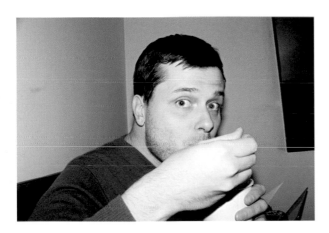

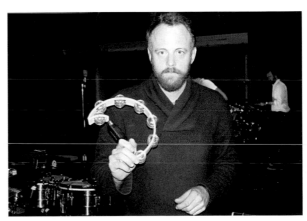

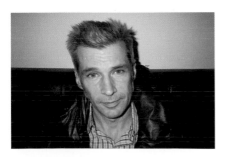

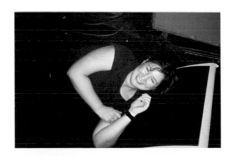

YEAH

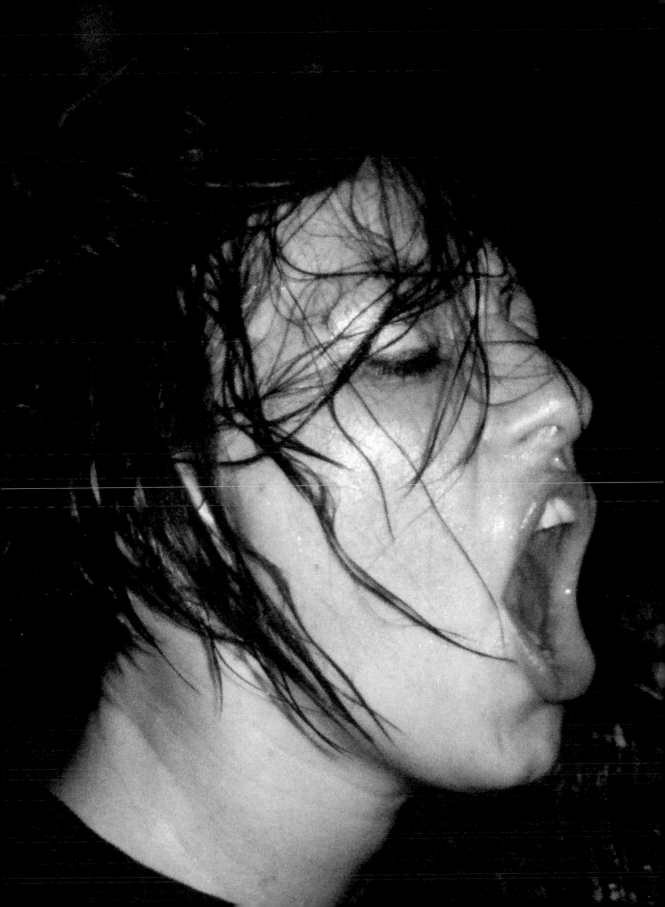

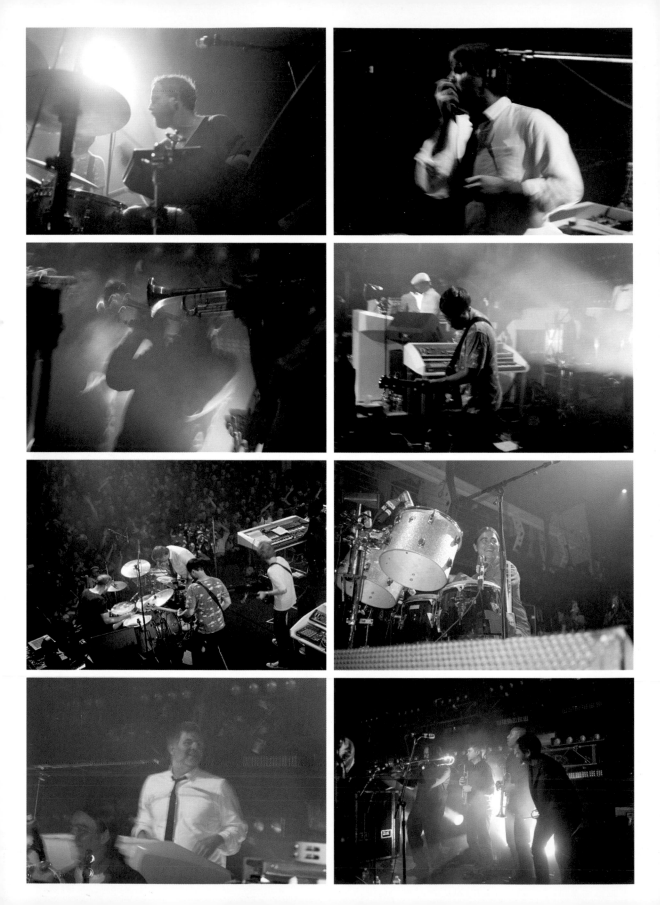

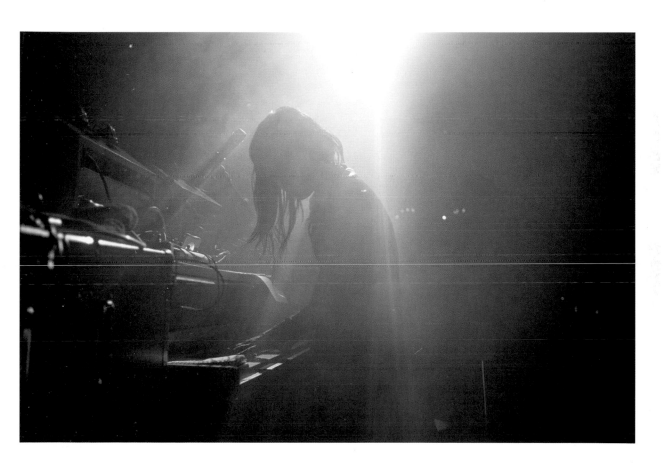

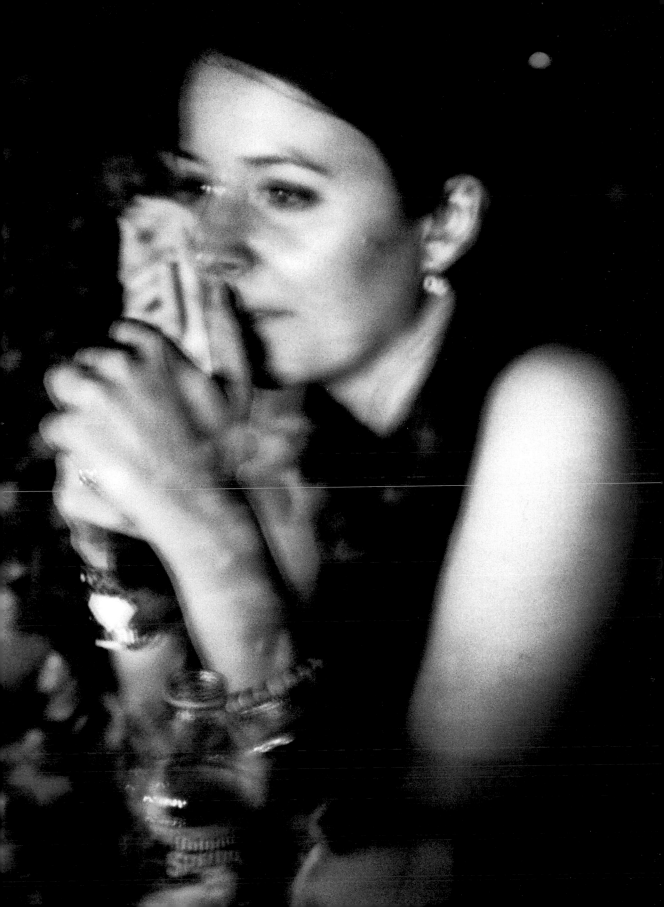

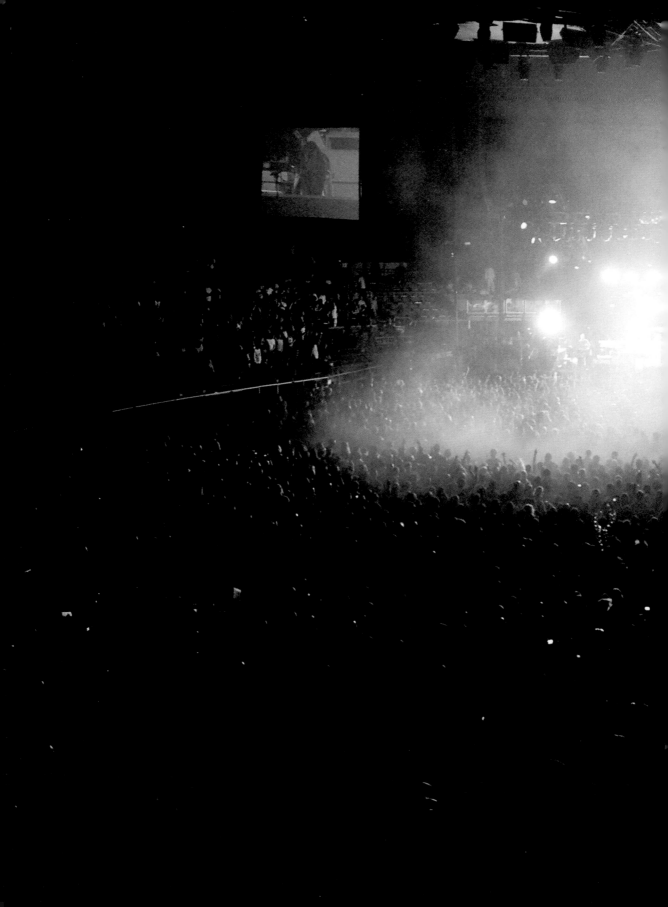

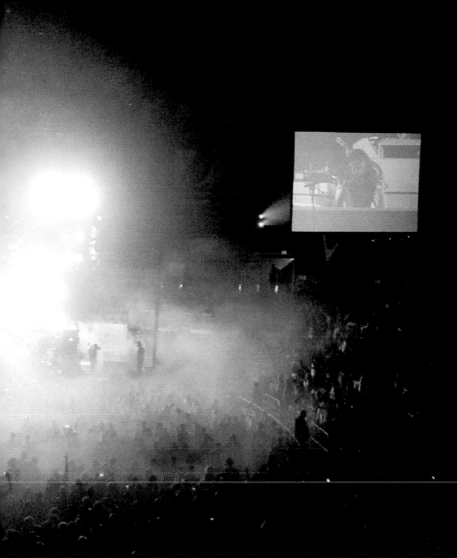

THE LAST SHOW

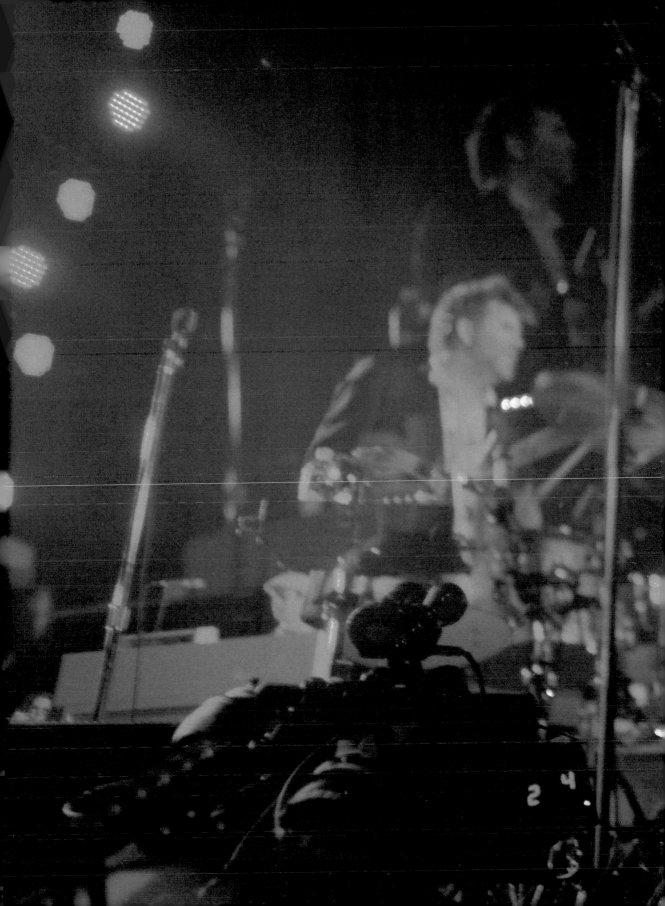

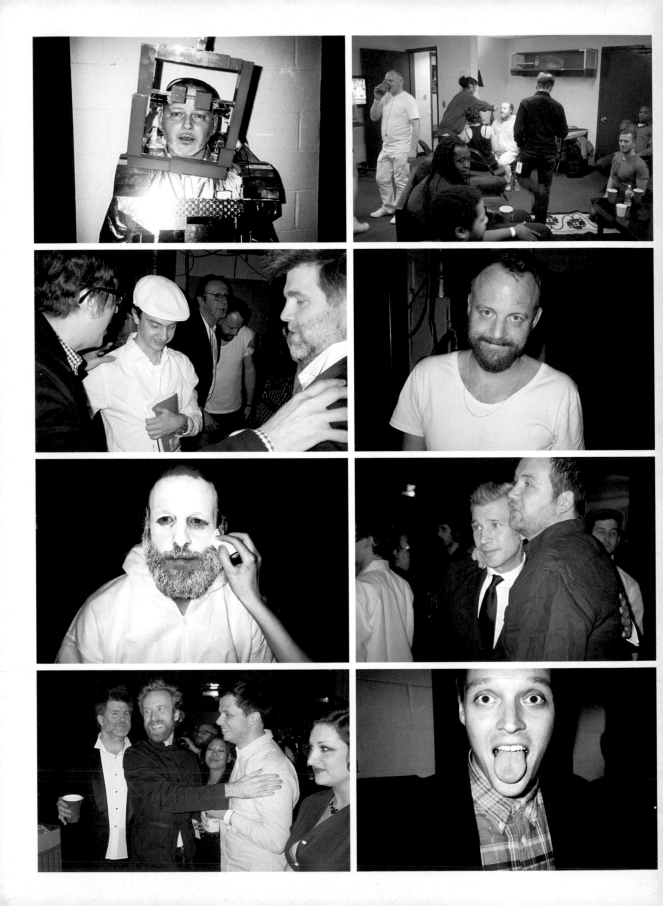

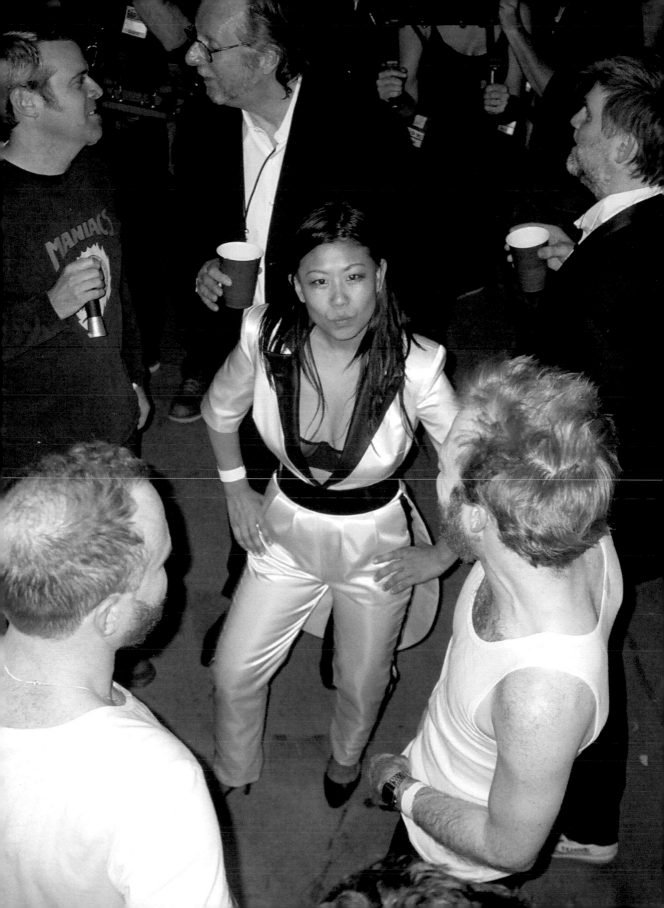

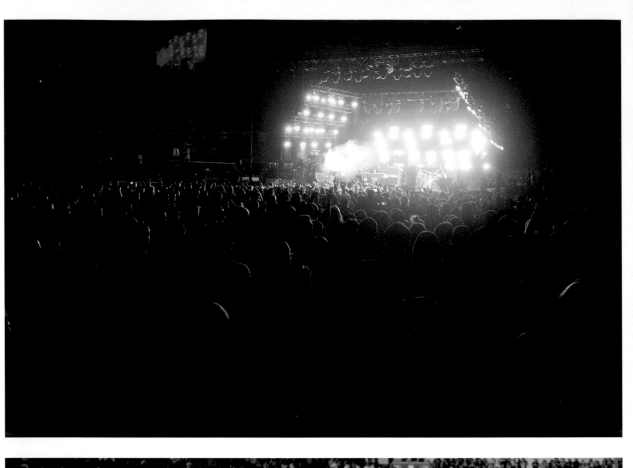

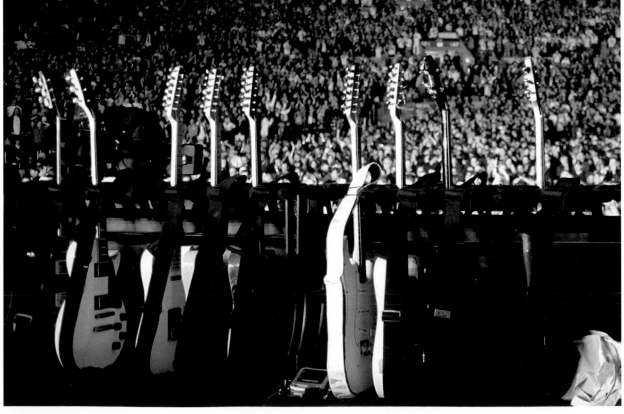

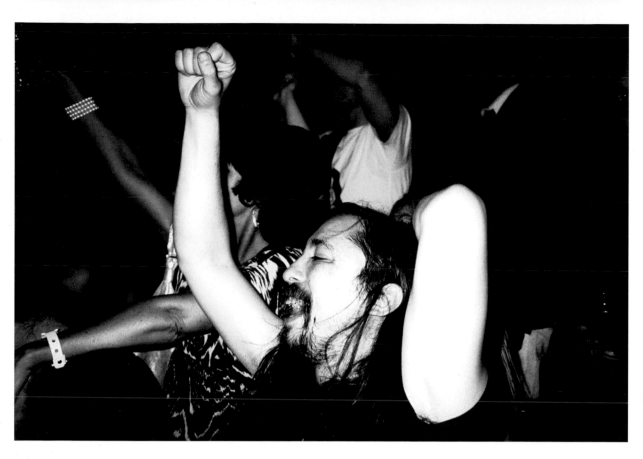
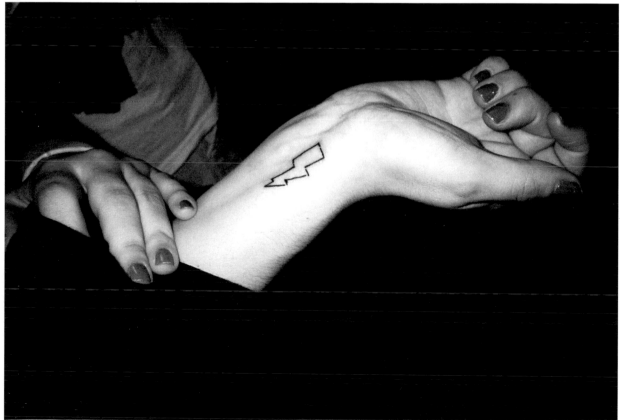

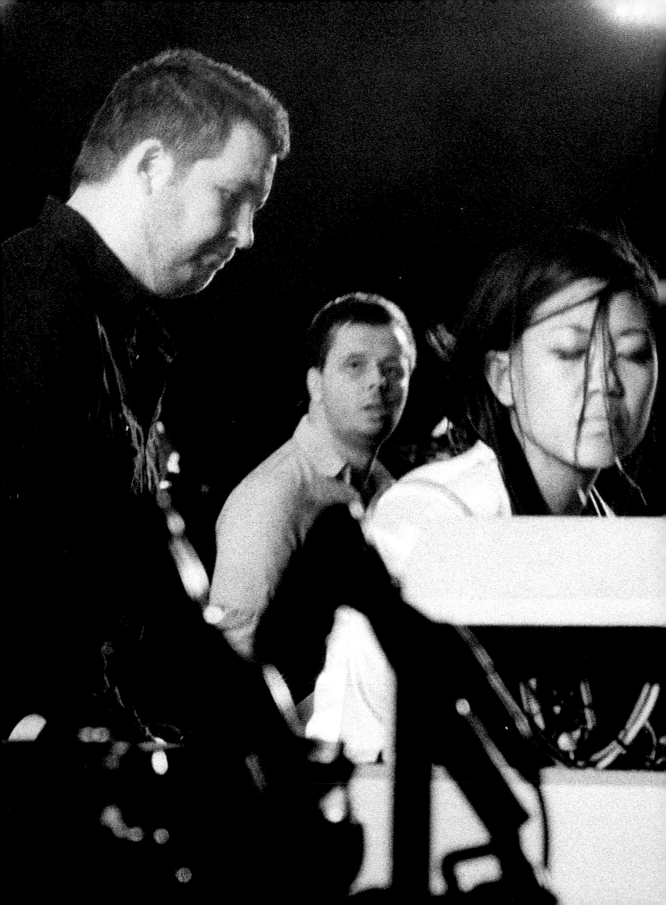

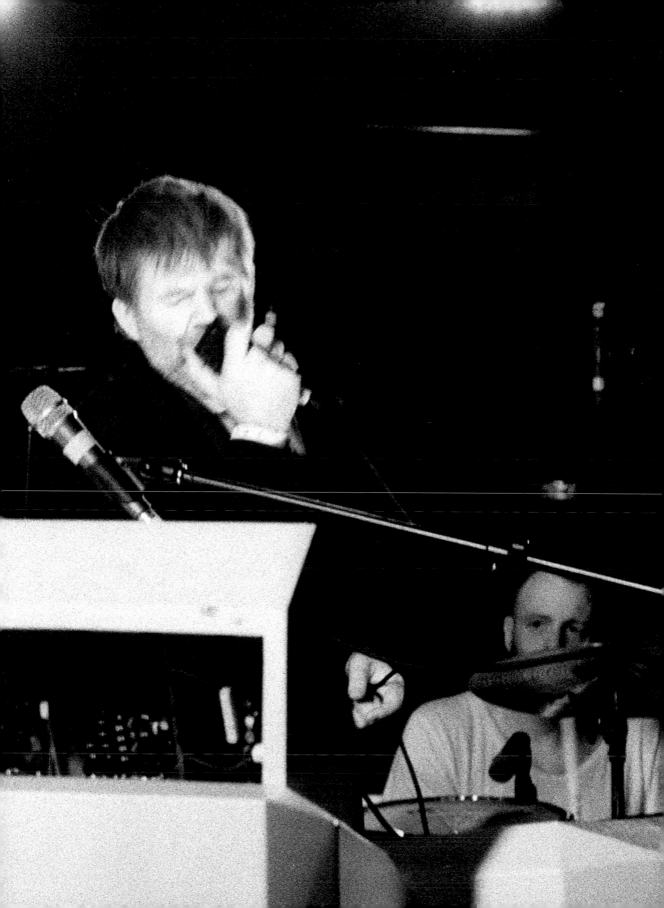

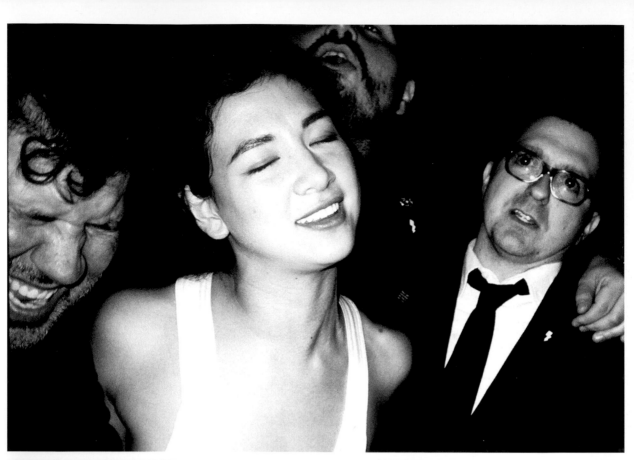
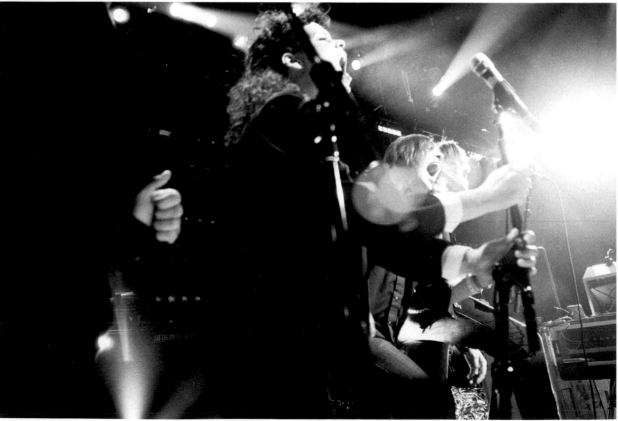

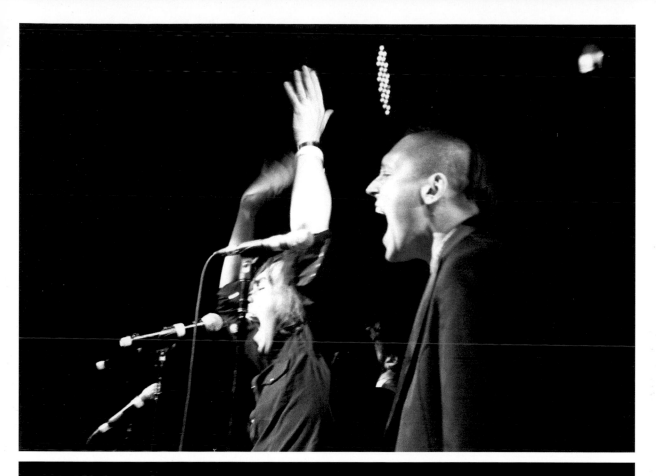

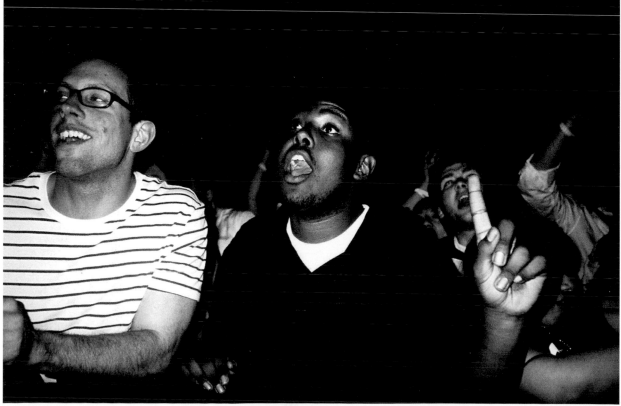

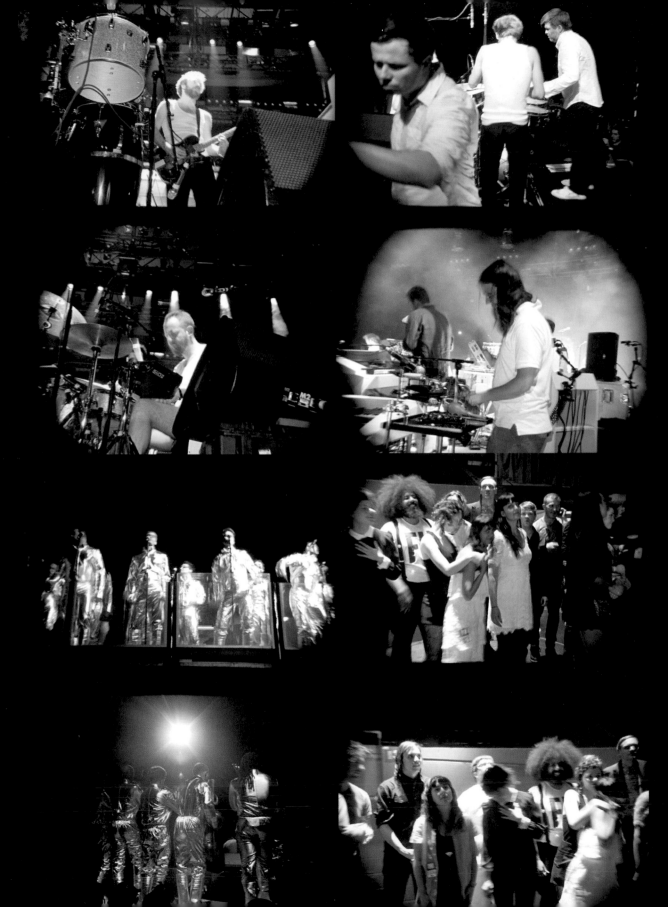

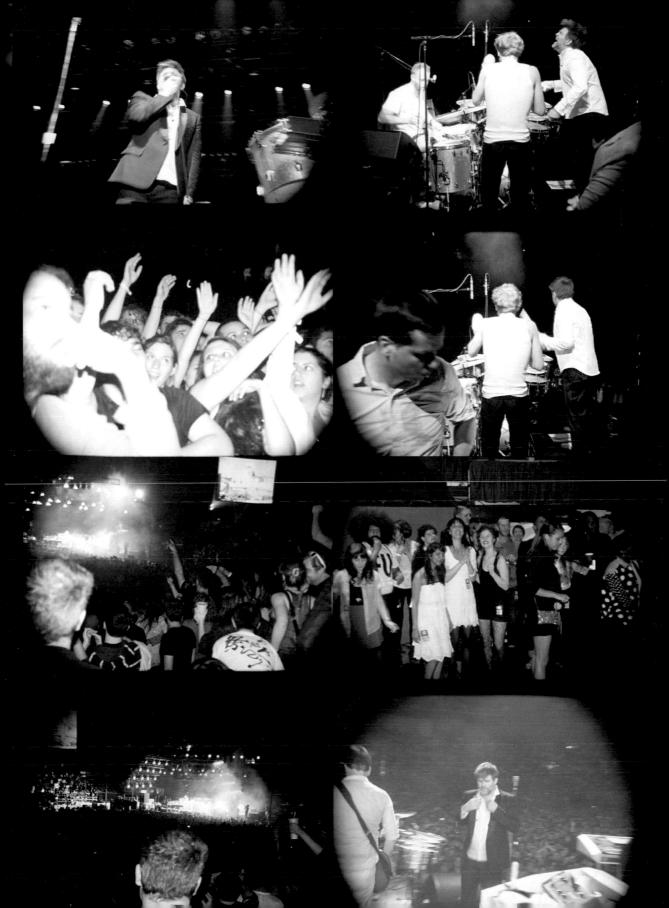

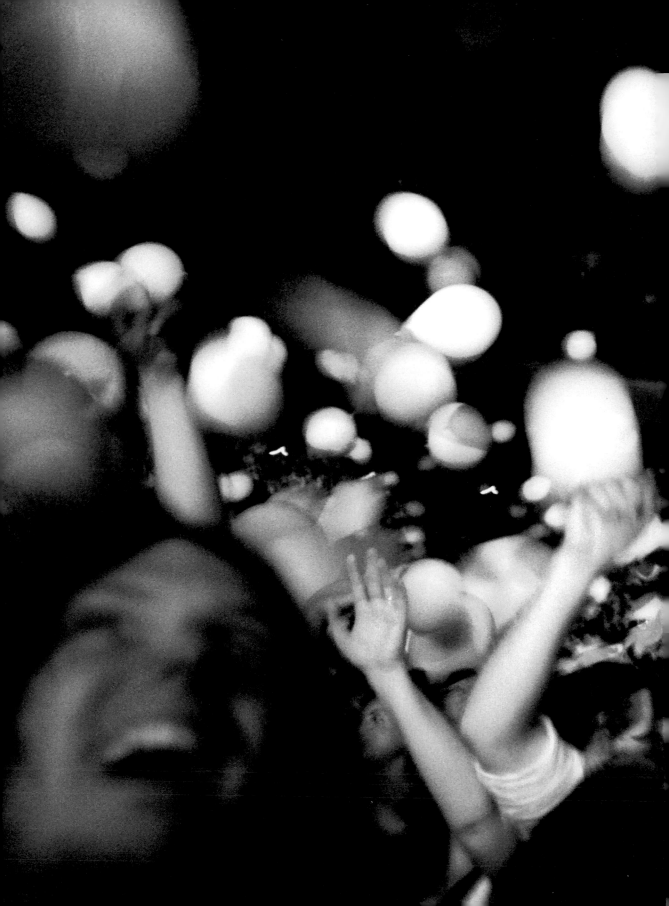

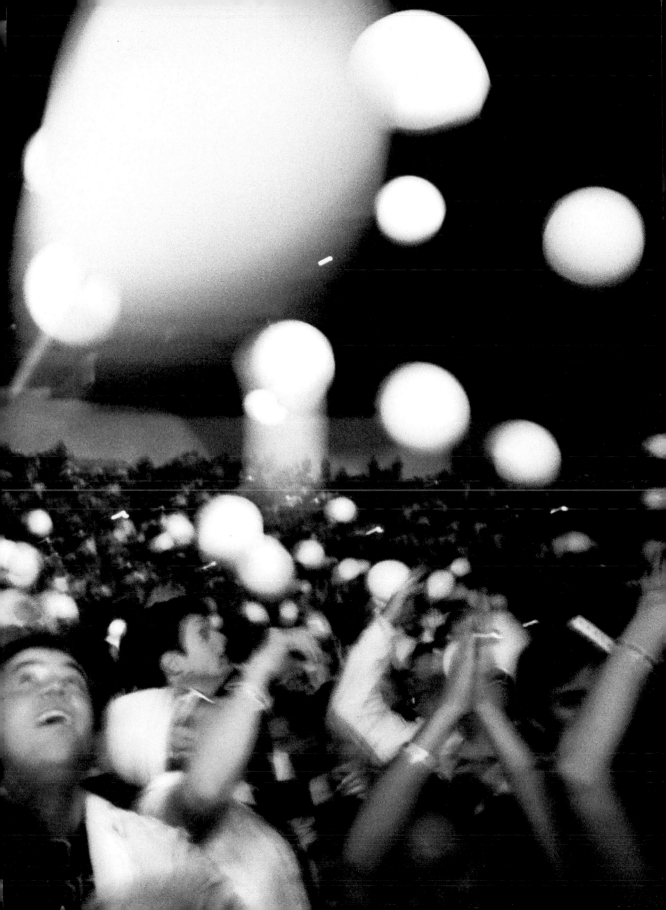

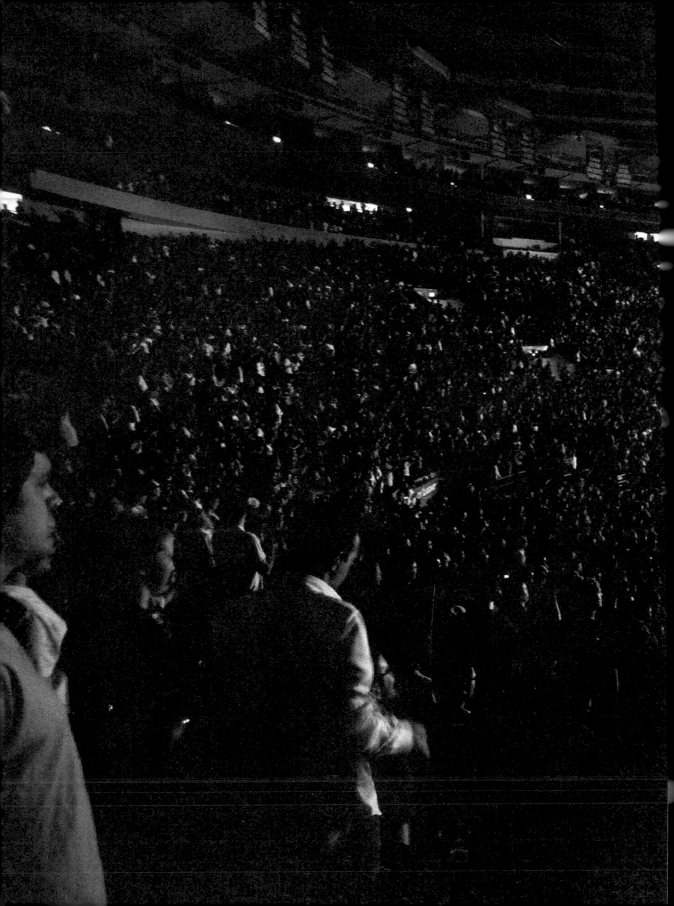

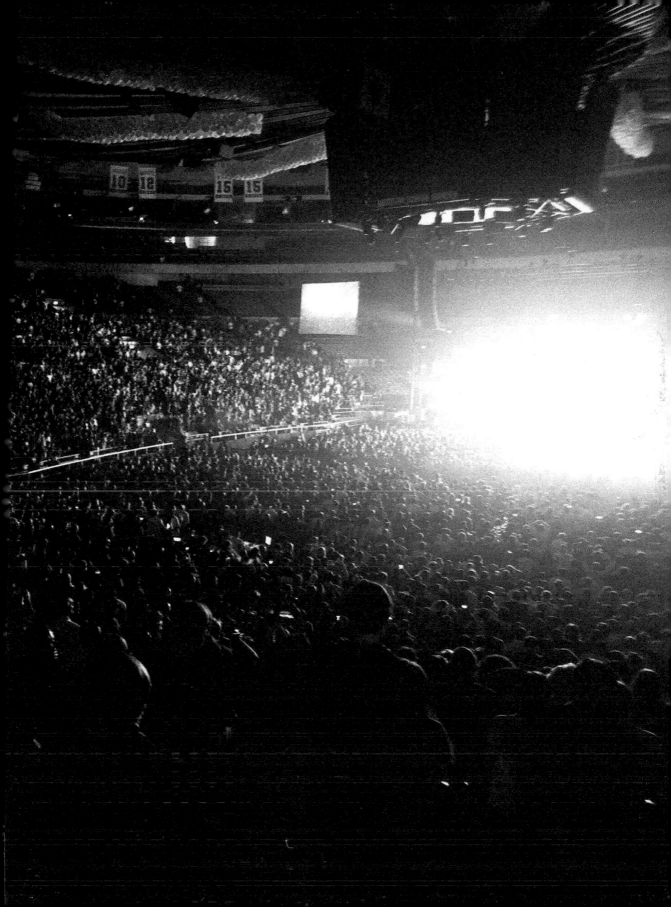

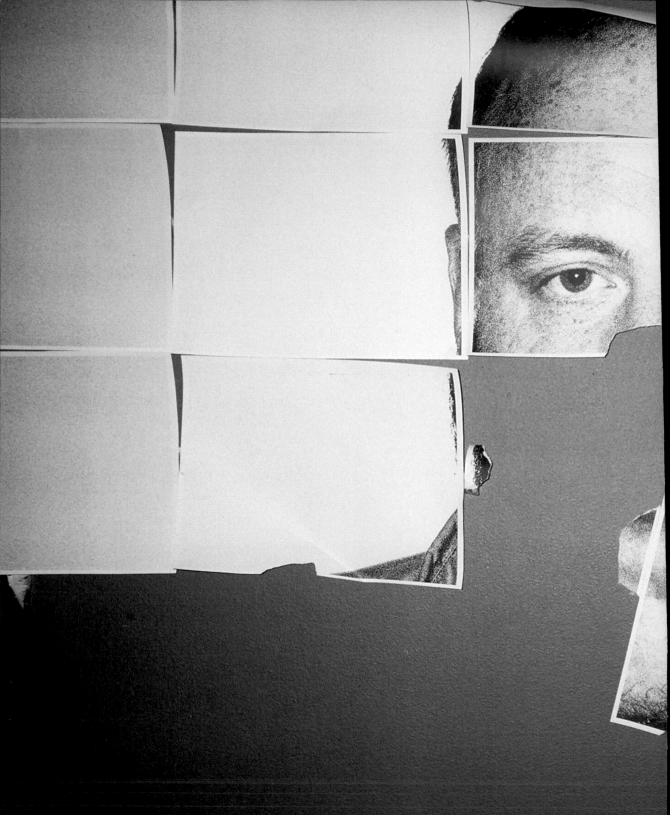

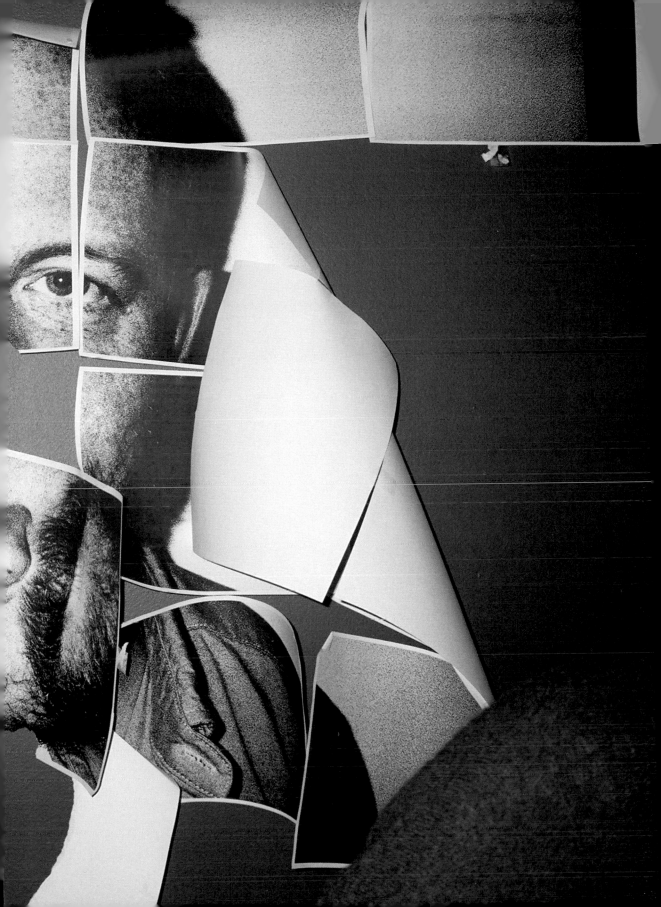

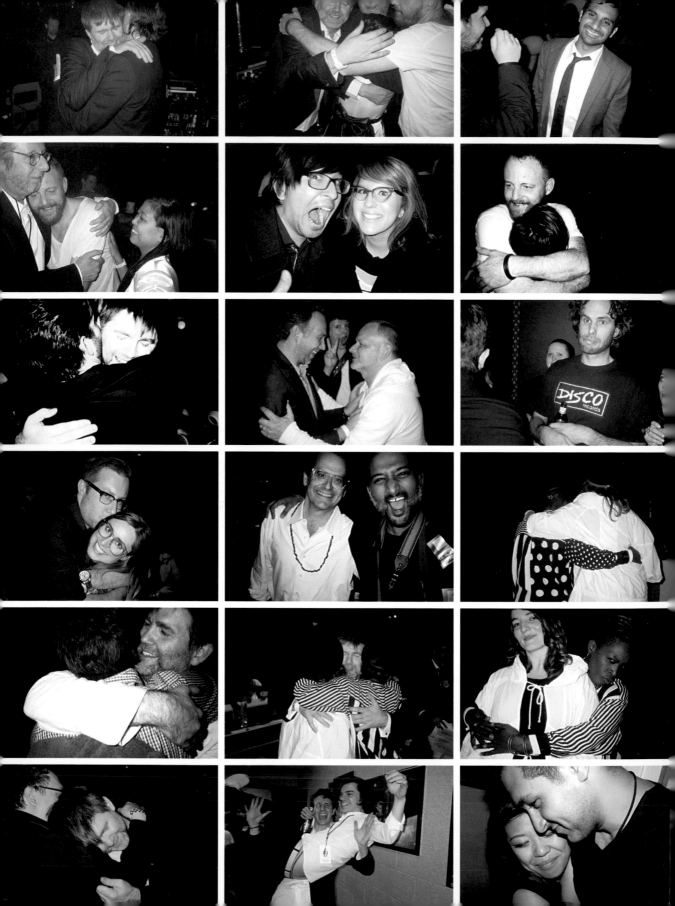

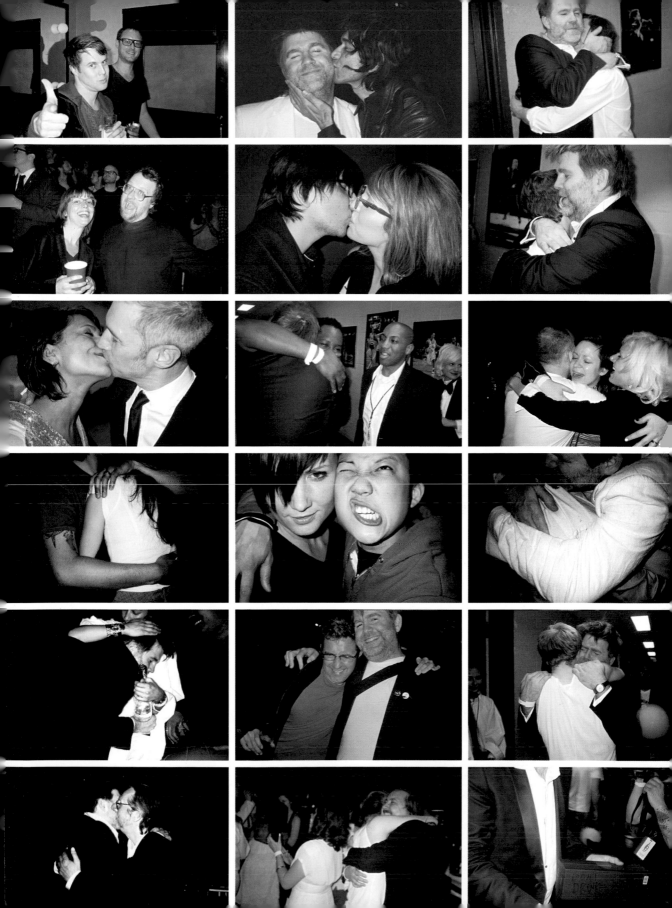

# THANK YOU

The too many and the so many. Hard to begin, nowhere to end.
These pages would have been blank if it weren't for you, who ended
up in this book. You're on the previous pages because Felix Swensson,
Malin Mårtensson, Peter Kaaden, Pablo Frisk, and Thomas Benski
decided you and I were worth it.

Deeply and greatly appreciated are all those with
The Pulse, The powerHouse, The DFA.

And The LCD—I don't actually know how many of you there are, but you
are out there and you know it. It's a big band beyond the instruments.
Had to save the best for last, Mom and Dad.

Love what you do.

## LCD

Photographs & Interviews © 2012 Ruvan Wijesooriya
Introduction © 2012 James Murphy
Book design by James Timmins
With support from **PULSE**

Published in the United States by powerHouse Books,
a division of powerHouse Cultural Entertainment, Inc.
37 Main Street, Brooklyn, NY 11201-1021
telephone 212.604.9074, fax 212.366.5247
e-mail: info@powerhousebooks.com
website: www.powerhousebooks.com

First edition, 2012

Library of Congress Control Number: 2012948893

ISBN 978-1-57687-628-2

A complete catalog of powerHouse Books and Limited Editions is
available upon request; please call, write, or visit our website.

10 9 8 7 6 5 4 3 2 1

Printed and bound in Italy by Gruppo Editoriale Zanardi.

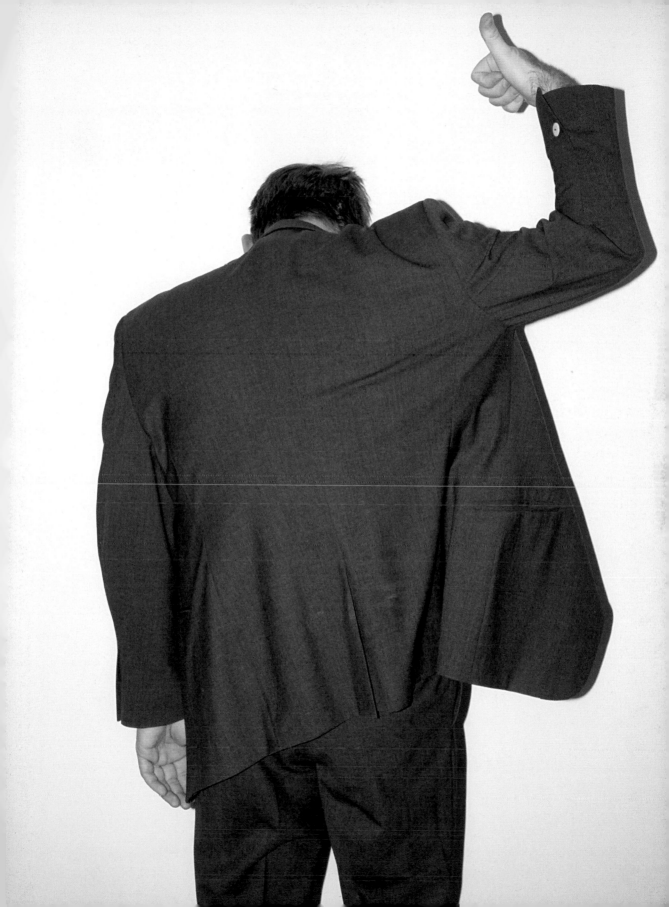

# NOTES

# NOTES